crude reflections | **cruda** realidad

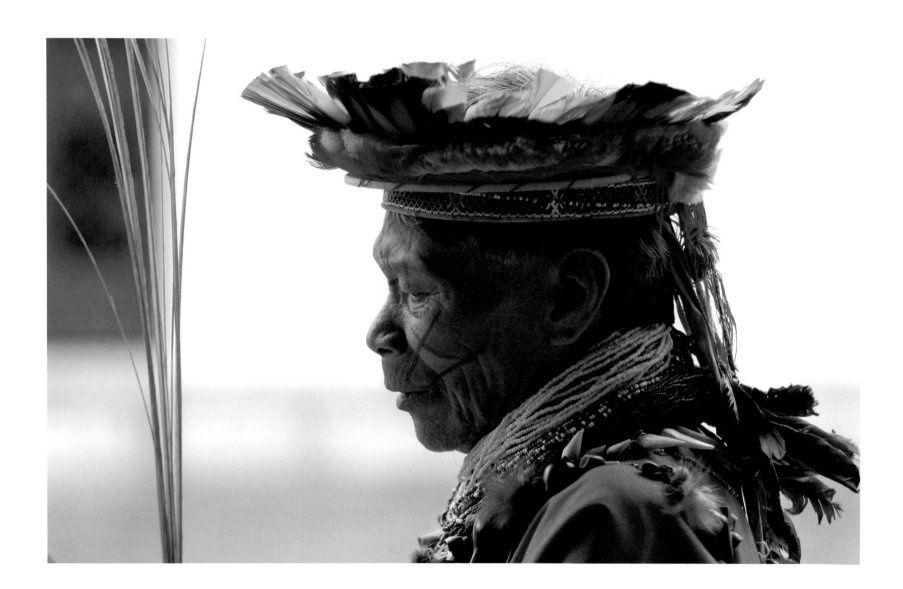

crude reflections | cruda realidad

OIL, RUIN AND RESISTANCE IN THE AMAZON RAINFOREST | PETRÓLEO, DEVASTACIÓN Y RESISTENCIA EN LA AMAZONÍA

Lou **Dematteis** Kayana **Szymczak**

foreword \| prólogo	**Trudie Styler & Sting**
epilogue \| epílogo	**Atossa Soltani**
reflections \| reflexiones	**Pablo Guayasamín**
testimonies \| testimonios	**Joan Kruckewitt & Gina Margillo**

City Lights Books
San Francisco

contents

5. Foreword | Prólogo—Trudie Styler and Sting

7. Introduction | Introducción
Lou Dematteis and Kayana Szymczak

11. Photographs | Fotografías
Color—Lou Dematteis
Black & White | Blanco y Negro—Kayana Szymczak

118. Map of Ecuador | Mapa del Ecuador

119. Epilogue | Epílogo—Atossa Soltani

123. Reflections | Reflexiones—Pablo Guayasamín

124. Map of the Texaco Concession Area
Mapa del Área Operada por Texaco

125. Supporters | Apoyo
Take Action | Actúa Ahora

126. Acknowledgments | Reconocimientos

pg. 2 | *Secoya elder Esteban Lucitante prays for peace before a march against Chevron (formerly Texaco).*
pág. 2 | *Esteban Lucitante, anciano Secoya, ora por la paz antes de una marcha en contra de Chevron (antes Texaco).*

foreword *by Trudie Styler and Sting*

As co-founders of the Rainforest Foundation and passionate environmentalists, we have been visitors to the rainforests of South America for the last 20 years as part of a mission to help indigenous forest peoples to protect their ancestral lands from exploitation and destruction. In all that time, we have never before witnessed the extent of human health problems and general suffering than in the oil fields of the rainforests of Ecuador.

In the 1960s prospecting for oil began in the Ecuadoran rainforest. At the time it was uncharted wilderness, a paradise on earth. But for 25 years of oil exploration and production, outmoded and U.S.-outlawed drilling practices were employed, resulting in the dumping of 18 billion gallons of toxic waste directly into the rivers and onto the ground. One thousand dump sites, unfenced and untreated, still leak their deadly toxins into the rivers and streams. Now that area has been described by independent assessors as one of the world's most contaminated industrial sites.

It's not only the land that is sick. The people of the region have been ingesting poisons for 40 years. Health studies confirm the chemicals contained in the toxic waste are linked with cancers and spontaneous miscarriages; childhood leukemia is four times the national average; and there are widespread skin and respiratory disorders. Entire communities are facing extinction: the Tetete have disappeared entirely; the Cofan, the Siona, the Secoya and the Huaorani peoples are all on the verge of extinction.

What has happened in Ecuador is not an isolated incident. Similar situations exist in remote rainforest areas all over the world. Big corporations move in and promise handouts—then they wreck the place, leaving indigenous peoples stricken, in decimated and deforested lands, with poisoned water. Nobody has been keeping watch.

In this collection of photographs, Lou Dematteis and Kayana Szymczak shine a light on a people who have captivated our hearts. They draw our attention to the exquisite beauty of the Amazon rainforest and her Ecuadoran indigenous peoples; but far from the gaze of the so-called first world, Lou and Kayana also reveal how callously they've been exploited and abused by the oil industry. Their poverty, their suffering, and their humanity leap off the pages and straight to your heart.

While their situation at first seems very far removed from our own lives, in fact we are connected to them in a very real way—by the pipelines we can see transporting their oil to our tankers. We cannot continue to unconsciously and irresponsibly condone the activities of unethical business and industrial practices. Our reliance on oil has created the problems these people are suffering. Now we have a responsibility to become part of the solutions.

The Rainforest Foundation is proud to be working alongside UNICEF Ecuador and the Frente de Defensa de la Amazonía to ameliorate this dire situation by providing a supply of clean water to the region. We hope that Lou Dematteis' and Kayana Szymczak's photographs will inspire everyone who sees them to take a more conscious and active stand against exploitative industries, and to campaign for people before profit in every part of the world.

prólogo *por Trudie Styler y Sting*

Como codirectores de la Fundación Rainforest, pero, sobre todo, como seres humanos apasionados por la naturaleza y cuidadosos del medio ambiente, hemos visitado repetidamente, durante los últimos veinte años, las selvas tropicales de Sudamérica, como parte de nuestra misión de apoyar a las comunidades indígenas para que protejan sus tierras ancestrales y se protejan a sí mismas de la explotación y la destrucción. Podemos afirmar que durante este lapso, en ninguna de nuestras visitas habíamos sido testigos de tan graves problemas de salud y sufrimiento humano y natural como los contemplados en las zonas aledañas a los pozos petroleros de la selva ecuatoriana.

En los años 60, comenzó la exploración petrolera de dichos territorios de selvas vírgenes, hasta entonces desconocidos. Pero los 25 años de actividades hidrocarburíferas con prácticas obsoletas prohibidas en los Estados Unidos, dejó como resultado dieciocho mil millones de galones de desechos tóxicos vertidos directamente en los ríos, arroyos y suelos. Hasta hoy, más de mil botaderos de desechos abiertos y sin tratamiento filtran tóxicos mortales a lo que aún resta de las fuentes de agua. Recientemente, estas tierras han sido descritas por asesores independientes como las áreas con mayor contaminación industrial del mundo.

No solamente la tierra está enferma. Los habitantes de la región han vivido estos últimos cuarenta años consumiendo tóxicos vertidos en sus posesiones, que según estudios de salud confirman que están íntimamente relacionados con enfermedades como el cáncer y abortos espontáneos; el índice de leucemia infantil en esta zona es cuatro veces más alta que el del promedio nacional; los problemas dermatológicos y respiratorios en los habitantes de esta región se han extendido. Existen comunidades enteras al borde de la extinción: los Tetete han desaparecido totalmente; los pueblos Cofán, Siona, Secoya y Huaorani están al borde de la extinción.

Lo sucedido en Ecuador no es una catástrofe aislada. Situaciones similares existen en zonas selváticas de todo el mundo. Grandes corporaciones ingresan prometiendo retribuciones, pero destruyen el lugar, dejando a los indígenas desolados, en tierras diezmadas, deforestadas, con fuentes de agua contaminada. Nadie está llevando la cuenta de esto.

Lou Dematteis y Kayana Szymczak, en esta colección de fotografías, muestran a las personas que cautivaron nuestros corazones. Dirigen nuestra atención hacia la belleza de la selva amazónica y la existencia de los pueblos indígenas ecuatorianos que la habitan; pero van más allá de la mirada superficial de las personas del primer mundo. Lou y Kayana también revelan la manera cruel y desalmada en la que sus habitantes han sido explotados y abusados por la industria petrolera. Su pobreza, sufrimiento y humanidad hieren desde estas páginas directamente nuestro corazón.

Aunque la situación de estas víctimas parezca muy alejada de nuestra realidad, estamos conectados con ellas a través de los oleoductos que llevan su petróleo a nuestros tanques. No podemos continuar justificando irresponsable e inconscientemente las actividades y prácticas industriales de empresas sin ética. Nuestra dependencia del petróleo ha creado los problemas que sufren estos antiguos pueblos. Tenemos la responsabilidad de ser parte activa de la solución.

Es un orgullo para la Fundación Rainforest trabajar con UNICEF Ecuador y con el Frente de Defensa de la Amazonía, para mejorar esta grave situación, suministrando agua potable a la región. Esperamos que las fotografías de Lou Dematteis y Kayana Szymczak inspiren a todas las personas que las vean y contribuyan a la toma de conciencia de esta situación insostenible, que las lleve a adoptar una posición activa en contra de las industrias extractivas y además que se unan a la campaña de poner a los seres humanos por delante de las ganancias en todos los rincones del mundo.

introduction *by Lou Dematteis*

I first traveled to Ecuador's northern Amazon region in 1993 to investigate reports of extensive environmental contamination and damage from years of oil development, and to photograph its consequences. I had been working as a photojournalist in Latin America for over a decade, spending much of that time covering the wars that raged throughout Central America. What I found in Ecuador was not a shooting war, but a war nonetheless—a war on the environment. I visited old Texaco (now Chevron)* oil well sites and saw toxic wastewater being dumped into open-air pits filled with crude oil that looked like infected sores on the floor of the rainforest. This was one of the results of Texaco's decision to dump oil waste into the environment instead of re-injecting it back into the earth. Even though Texaco left Ecuador in 1992, the dumping continued at its old wells and facilities. To make matters worse, many pits were set on fire in order to burn away the waste crude, a practice started by Texaco. The scene looked like something out of Dante's Inferno.

During my trip, I spoke with a doctor at Ecuador's Ministry of Health. He believed the region was sitting on a time bomb as a result of the toxic waste contamination. He said it would take 10 years or so for cancers and other health problems to fully manifest themselves, but when they did, the result would be an epidemic of serious and fatal health conditions. When I returned to the northern Amazon again in 2003 to cover the opening of the trial against Chevron (formerly Texaco), I found that the time bomb had exploded. Everywhere I turned, I encountered people with cancer, birth defects, respiratory ailments and other severe health problems.

We often hear of environmental catastrophes but almost never meet the people who suffer the consequences. In Ecuador's case, I was determined to give a voice to the people who were living with the impacts of this ecological tragedy. Returning again in 2004 for the start of judicial inspections of old Texaco wells and waste sites, I stayed on after my initial assignment to photograph some of those affected by the contamination. One of the first people I photographed was Angel Toala, who had been an activist with the Amazon Defense Front.** Angel was dying from stomach cancer and was so weak he couldn't speak. His wife spoke for him. Her testimony is in this book. I found out later that Angel died the day after I took his photo.

Since Angel's death, I have continued to visit the Amazon, to tell the stories not only of people like him, but also of the movements to protect and preserve the rainforest. In 2006, I traveled to Ecuador's southern Amazon to visit the Kichwa of Sarayaku and the Achuar territories farther south. I learned of the Kichwa and Achuar peoples' long history of opposition to petroleum exploration and extraction, and of their struggle to protect their rights, their homelands and their cultures. In 2007, I traveled to the Yasuni National Park, one of the most biodiverse areas of rainforest in the world. I was there for the launch of a campaign to save the park from oil development. Organizers and supporters of the campaign seek international monetary support for a pioneering plan to forgo oil extraction and protect the rainforest. The plan has received strong support both within and outside Ecuador.

I am privileged to have been able to photograph the people of the Amazon and to have been entrusted with their stories. My hope is that by sharing these images, I will not only help the people who live there to obtain the justice they so well deserve, but help the wider world to appreciate the precious resource the rainforest is, so action can be taken to defend and preserve it for the benefit of all humankind.

* In 2001 Chevron acquired Texaco and renamed the company ChevronTexaco. In 2005, Texaco was dropped, and today the corporation is again known as Chevron.

** The Amazon Defense Front is a grassroots organization dedicated to environmental justice in the area where Texaco operated.

introducción *por Lou Dematteis*

En 1993 viajé por primera vez a la región norte de la Amazonía ecuatoriana para investigar sobre los informes respecto al enorme daño ambiental y la contaminación producida por el desarrollo de actividades petroleras durante años y para captar en fotografías sus consecuencias. Por más de una década había trabajado como reportero gráfico en América Latina pasando mucho de este tiempo cubriendo las guerras que se vivieron en Centro América. Lo que encontré en Ecuador no fue una guerra de disparos, sino una guerra contra el medio ambiente. Visité los viejos pozos de Texaco (actualmente Chevron)* y pude ver aguas residuales tóxicas siendo vertidas a las piscinas descubiertas llenas de crudo que parecían llagas abiertas en el suelo de la selva. Esta fue una de las consecuencias de la decisión de Texaco de derramar los desechos de la producción petrolera en el medio ambiente, en vez de reinyectarlos. Aunque Texaco dejó el área en 1992, el vertimiento continúa en sus viejos pozos e instalaciones. Para empeorar las cosas, muchas de las piscinas fueron incendiadas para quemar los residuos del crudo, una práctica que fue iniciada por Texaco. La escena parecía sacada del Infierno de Dante.

Durante esta visita hablé con un médico en el Ministerio de Salud del Ecuador. Él consideraba que la población Amazónica vivía sobre una bomba de tiempo a consecuencia de la contaminación con desechos tóxicos. Entonces aseveró que en el lapso de 10 años, se manifestaría su impacto, reflejado en cáncer y otras enfermedades, con serias y fatales consecuencias. Cuando regresé de nuevo a la región en el año 2003, para cubrir el inicio del juicio en contra de Chevron (antes Texaco), me di cuenta de que la bomba había explotado. En cada lugar que iba encontré gente con cáncer, defectos de nacimiento, enfermedades respiratorias y otros problemas graves de salud.

A menudo escuchamos sobre las catástrofes ambientales, pero casi nunca tenemos la oportunidad de conocer a las personas que sufren sus consecuencias. En el caso de Ecuador, estaba determinado a darle una voz a las personas que estaban viviendo los impactos de esta tragedia ecológica.

Cuando regresé en el año 2004 para el inicio de las inspecciones judiciales de los antiguos pozos y sitios de desechos tóxicos de Texaco, me dediqué a fotografiar a algunas de las personas afectadas por la contaminación. Una de las primeras personas que fotografié fue Ángel Toala, quien había sido un activista del Frente de Defensa de la Amazonía.** Ángel agonizaba con cáncer de estómago y estaba tan débil que no podía hablar. Su esposa habló por él y su testimonio forma parte de este libro. Luego me enteré de que Ángel había muerto un día después de que tomé esta fotografía.

Desde la muerte de Ángel, he continuado visitando Ecuador, para contar las historias no sólo de personas como él, pero también las historias de los movimientos que han surgido para proteger y preservar la selva. En el año 2006 viajé al sur de la Amazonía ecuatoriana a la comunidad Kichwa de Sarayaku y los territorios Achuar que se encuentran más al sur. Allí conocí la larga e histórica oposición de los pueblos Kichwa y Achuar a la exploración y extracción de petróleo en su tierra y de su lucha para proteger sus derechos, su territorio y su cultura. En el año 2007, viajé al Parque Nacional Yasuní, una de las regiones de bosque tropical con mayor biodiversidad en el mundo. Estuve allí durante el lanzamiento de la campaña para salvar el parque del desarrollo petrolero. Los organizadores y partidarios buscan apoyo monetario internacional para su plan vanguardista de no explotar el petróleo sino más bien proteger el bosque tropical del parque. El plan ha recibido un gran apoyo tanto fuera como dentro de Ecuador.

Tuve el privilegio de haber fotografiado a los habitantes de la Amazonía y de que me hayan confiado sus historias. El compartir estas imágenes no sólo lleva la esperanza de apoyar a las personas que habitan esa importante región, para que obtengan la justicia que merecen, sino también de ayudar a que el mundo valore el precioso recurso que es la selva tropical y la defiendan y preserven para beneficio de la humanidad.

** En el 2001 Chevron adquirió a Texaco y nombró la compañia ChevronTexaco. En el 2005, quitaron Texaco y hoy la compañia se conoce otra vez como Chevron.*

*** El Frente de Defensa de la Amazonía es una organización de base dedicada a luchar por la justicia ambiental en el área donde operaba Texaco.*

introduction *by Kayana Szymczak*

The ongoing quest for oil is reaching into the most pristine and least inhabited environments, not only decimating the land, but also threatening the virtual extinction of remote indigenous cultures around the world. I visited the Ecuadoran Amazon knowing that I would see the impacts of contamination on the environment, the culture, and the health of the communities living in the wake of Texaco's (now Chevron) oil development. Nevertheless, I was completely unprepared for the level of devastation that I encountered—children born with tragic birth defects, toxic oil facilities built in families' backyards, and indigenous communities facing total cultural extinction.

On my first day in the field, I visited a couple, Jose Mashumar and Maria Antuash, who had personally experienced the tragedy of this unconscionable exploitation. Against their protests, Texaco built an oil facility on their property, with flares and oil waste pits only a hundred yards from their home. As a result, their two teenage daughters died of illnesses linked to their exposure to the contamination. While I visited them in their home, the heat, smoke and fumes from the facility were nearly unbearable. I struggled to imagine living in conditions where the air, the soil, and even the water could be fatally dangerous to myself and my children. It was the brutal beginning of an eye-opening trip, where daily I was shocked at the depth of the destruction. As I traveled throughout the area, I became determined to tell the story of the brave people who are facing this ongoing hardship and demanding justice.

I have attempted to bear witness to the reality of life in the Ecuadoran Amazon today. These photographs are visual testimonies of the real price that is being paid in our endless pursuit for more oil. It is my hope that these images highlight our collective responsibility to demand an end to these destructive practices and to heal the damage that has already been done. Most important, I hope that these images inspire viewers to support communities around the world whose struggle—for basic human rights, justice and even their survival—continues.

introducción *por Kayana Szymczak*

La continua búsqueda de petróleo avanza hasta los lugares más prístinos y menos habitados, dañando no solamente la tierra, sino amenazando también con extinguir remotas culturas indígenas alrededor del mundo. Visité la Amazonía ecuatoriana sabiendo que iba a presenciar los impactos que la contaminación causa sobre el medio ambiente, la cultura y la salud de las comunidades que viven en los sitios de explotación petrolera de Texaco (actualmente Chevron). Sin embargo, no estaba preparada para la devastación que encontré—niños con trágicas malformaciones de nacimiento, instalaciones petroleras en los patios de las casas y comunidades indígenas enfrentando la pérdida total de su cultura.

Durante mi primer día de trabajo en el campo, visité a José Mashumar y María Antuash, quienes vivieron personalmente la tragedia de esta explotación inconsciente. A pesar de sus protestas, Texaco construyó una planta de operaciones en su propiedad, con mecheros y piscinas de desechos de petróleo a corta distancia de su casa. Como resultado de esto, sus dos hijas adolescentes murieron por enfermedades relacionadas con la exposición a la contaminación. Mientras visitaba su casa, el calor, el humo y los gases que emanaban de la planta eran casi insoportables. Fue difícil imaginarme la vida bajo estas condiciones en las que el aire, el suelo y hasta el agua pueden ser fatalmente peligrosas para mi y mis hijos. Este fue el brutal inicio de un viaje que me abrió los ojos, en el que cada día me impactaba la gravedad de la destrucción, y decidí, mientras viajaba por el área, contar la historia de estas valientes personas que viven esta verdad y demandan justicia.

He tratado de ser testigo de la realidad que se vive en la Amazonía ecuatoriana. Estas fotografías son testimonios visuales del costo real que se paga a consecuencia de nuestra búsqueda sin fin por el petróleo. Espero que estas imágenes despierten nuestra responsabilidad colectiva para exigir que se terminen estas prácticas destructivas y para sumarnos a la exigencia de reparación del daño causado.

Lo más importante es que estas imágenes puedan inspirar a los espectadores para que brinden su apoyo a las comunidades alrededor del mundo que continúan en la lucha por el respeto a sus derechos humanos, por la justicia y por su supervivencia.

For all of the courageous people who let us into their lives to bear witness to their struggle—we hope this work will serve to support the fight for health, justice and human rights in the Amazon.

A todas las valientes personas que nos permitieron entrar en sus vidas para ser testigos de su lucha—esperamos que este trabajo sirva para apoyar la lucha por la justicia, la salud y los derechos humanos en la Amazonía.

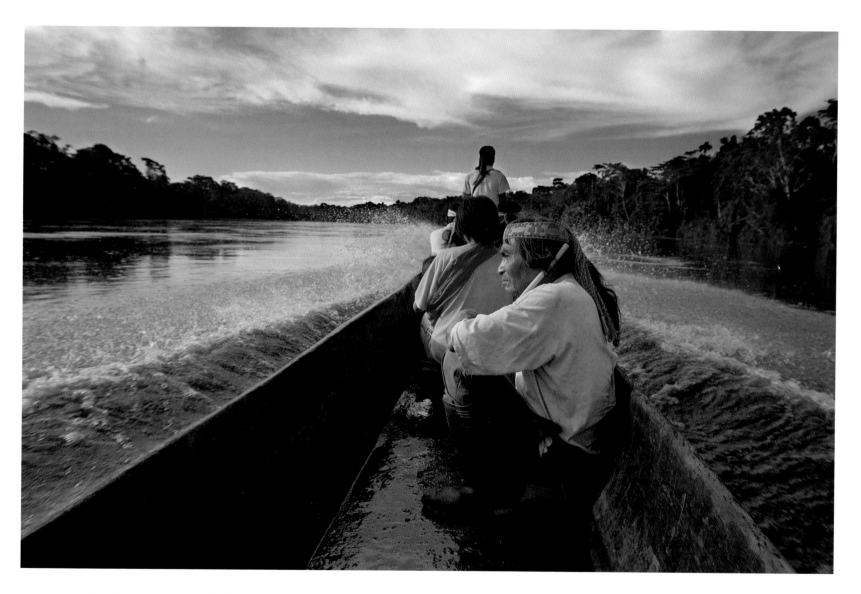

Traveling by canoe with the Achuar on the Pastaza River to the village of Sharamentza.

En camino a Sharamentza viajando en canoa por el Río Pastaza con los Achuar.

Kapawi Lagoon in the rainforest in Achuar territory in the southern Amazon.

Laguna de Kapawi en la selva territorio Achuar al sur de la Amazonía.

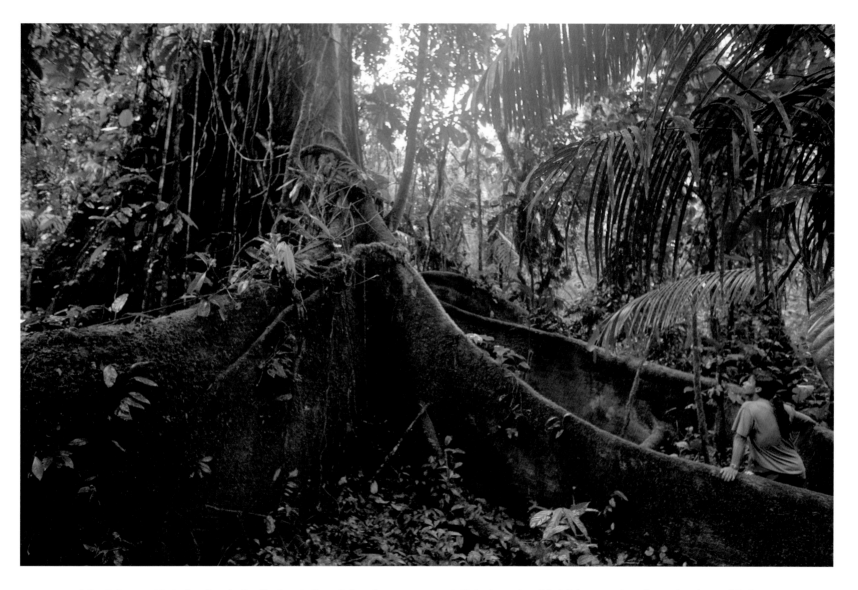

An Achuar guide looks at a giant ceiba tree in the rainforest near the village of Kapawi.

Guía de nacionalidad Achuar contempla un gigantesco árbol ceiba en la selva cerca de la comunidad de Kapawi.

A canoe travels down the Bobonaza River through the Kichwa community of Sarayaku.

Canoa desplazándose por el Río Bobonaza hacia la comunidad Kichwa de Sarayaku.

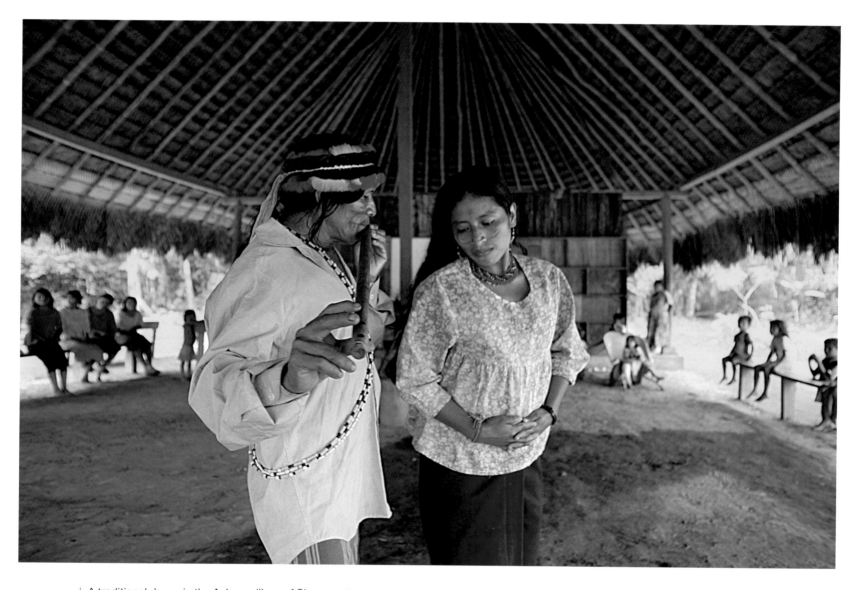

| A traditional dance in the Achuar village of Sharamentza. | Baile tradicional en el pueblo Achuar de Sharamentza.

pgs. 16-17 | A view of the Pastaza River, a major tributary of the Amazon River, in the Achuar territory of the southern Amazon.
págs. 16-17 | Panorama del Río Pastaza, afluente del Río Amazonas, en el territorio Achuar en el sur de la Amazonía.

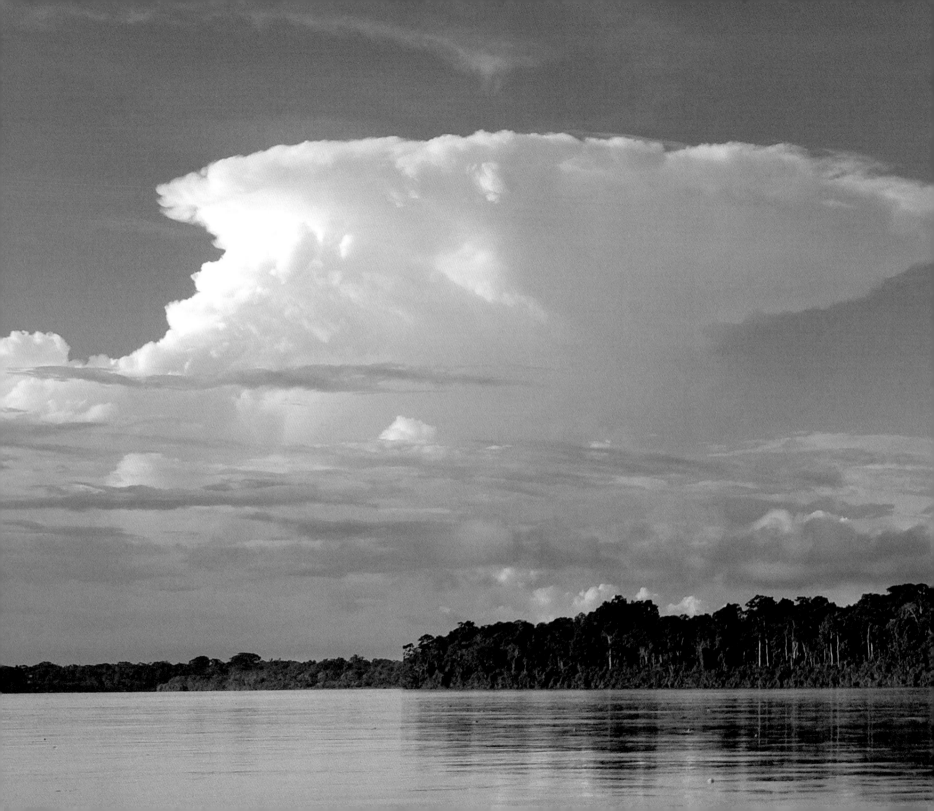

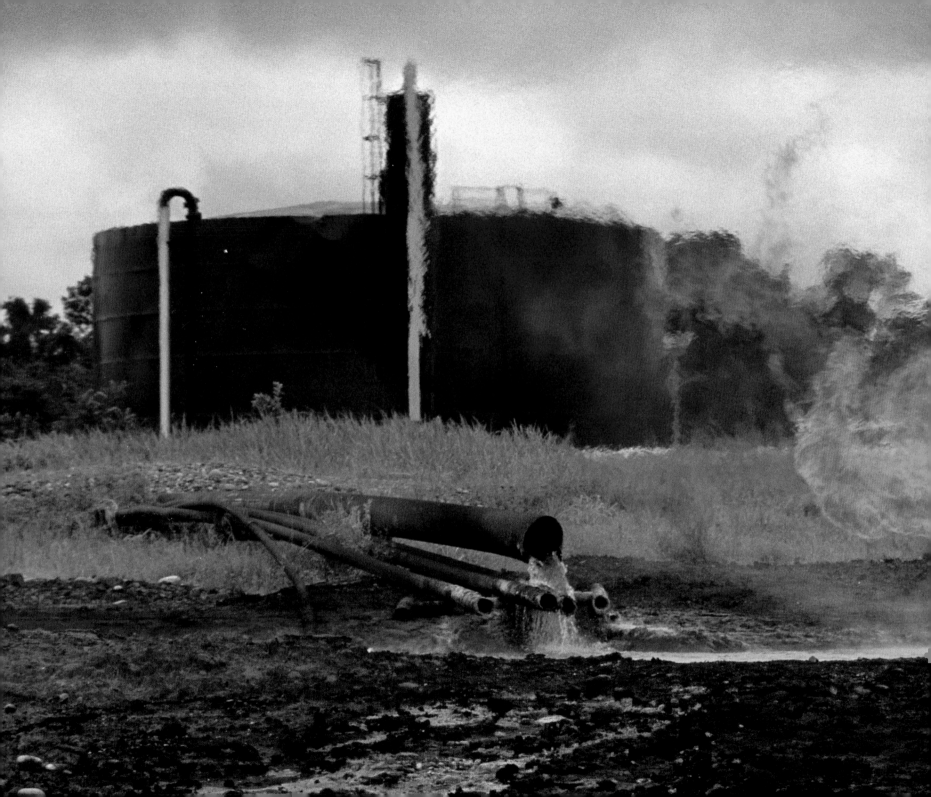

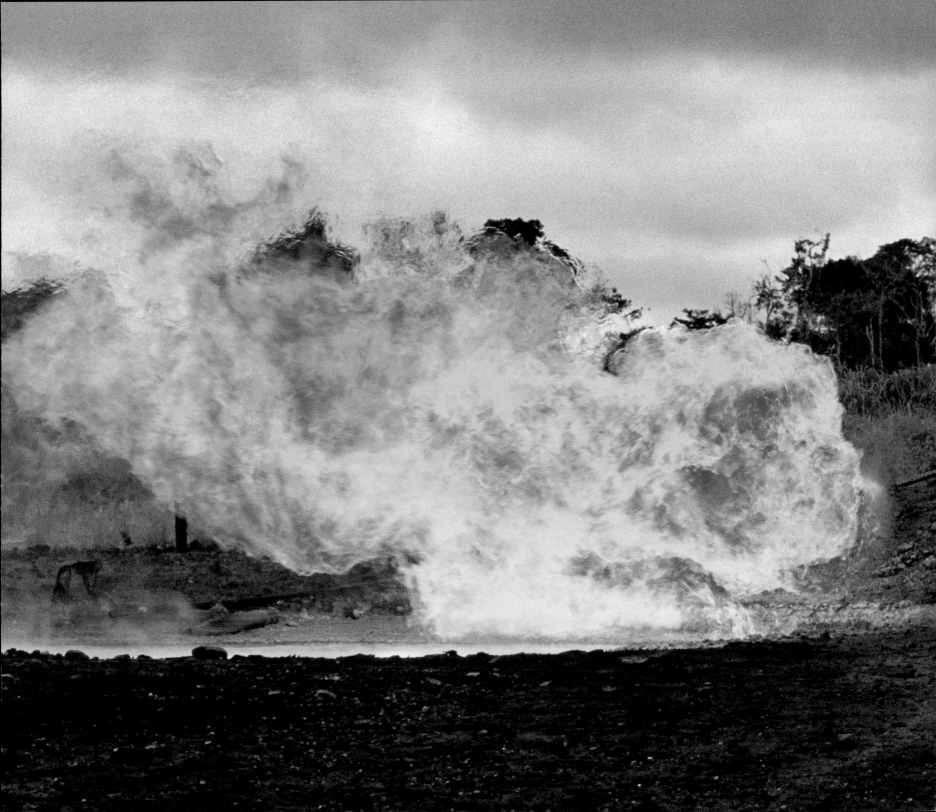

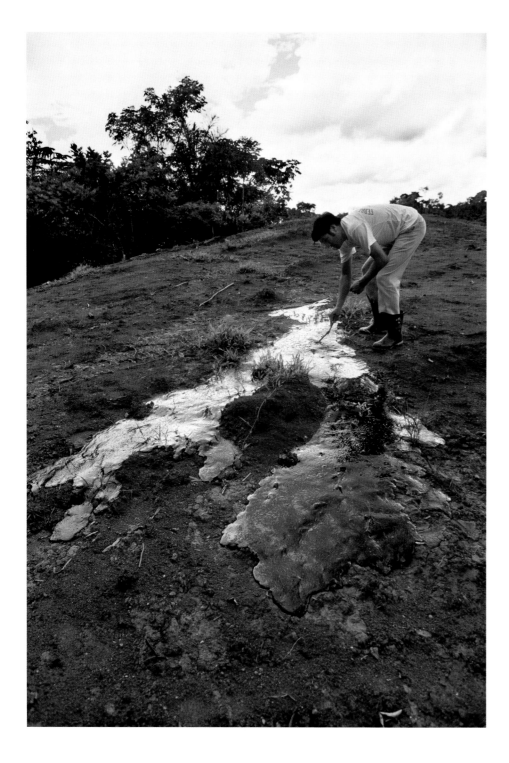

pgs. 18-19 | *Oil waste pit fire in Shushufindi in 1993.*
págs. 18-19 | *Fuego en la piscina de desechos tóxicos
de petróleo en Shushufindi en 1993.*

Oil rises to the surface from a waste pit covered with dirt near Coca in 1993.

Petróleo crudo brotando de una piscina cubierta con tierra cerca de Coca en 1993.

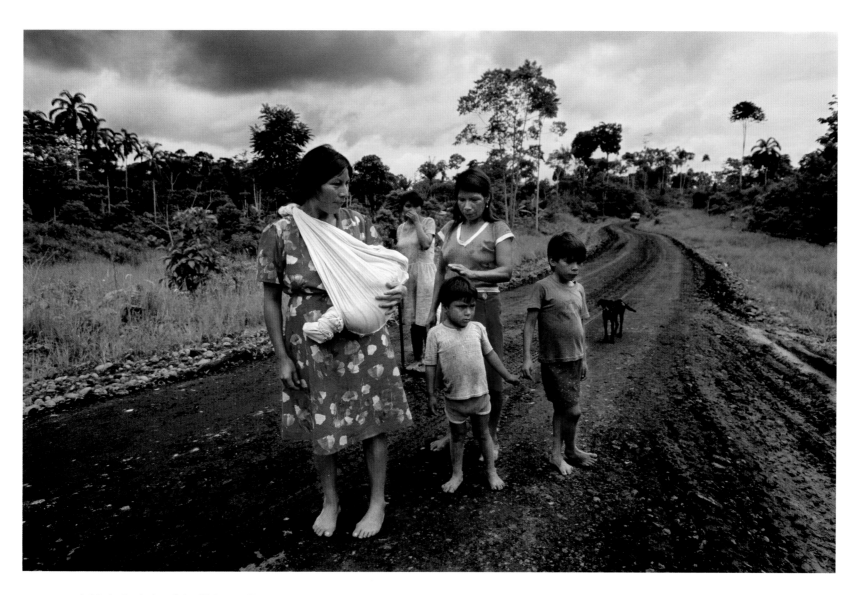

Maria Aguinda, of the Kichwa indigenous group, with her family on the oil-soaked Via Auca in the family's village of Rumipamba in 1993. Aguinda is the lead plaintiff in the class-action lawsuit against Chevron (formerly Texaco) seeking a cleanup of petroleum contamination in the Amazon rainforest.

María Aguinda, de nacionalidad Kichwa, junto con su familia en la Vía Auca inundada de petróleo en el pueblo de Rumipamba en 1993. Aguinda es la demandante principal en el proceso judicial en contra de Chevron (antes Texaco) que busca la reparación ambiental de la selva Amazónica, contaminada por la explotación petrolera.

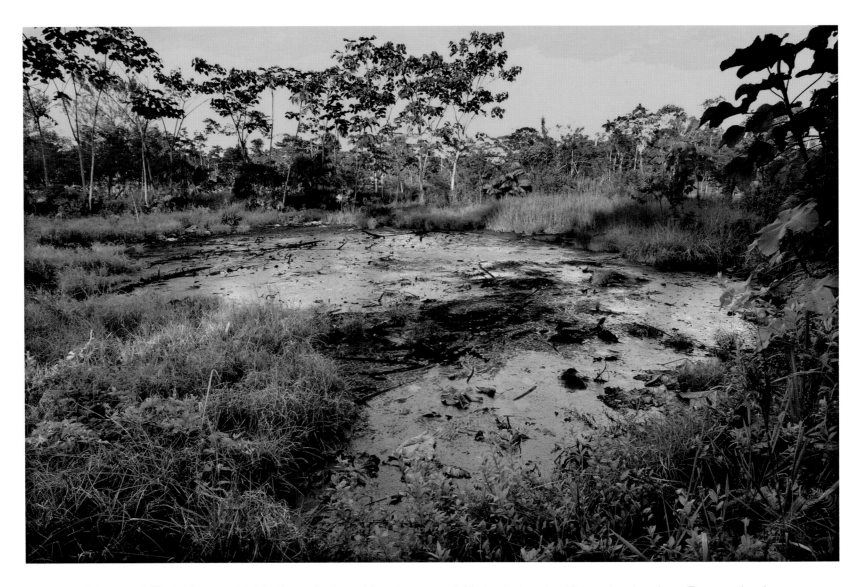

A waste pit filled with crude oil left by Texaco lies in a rainforest clearing near the town of Sacha.

Piscina de desechos tóxicos abandonada por Texaco en la selva cerca del pueblo de Sacha.

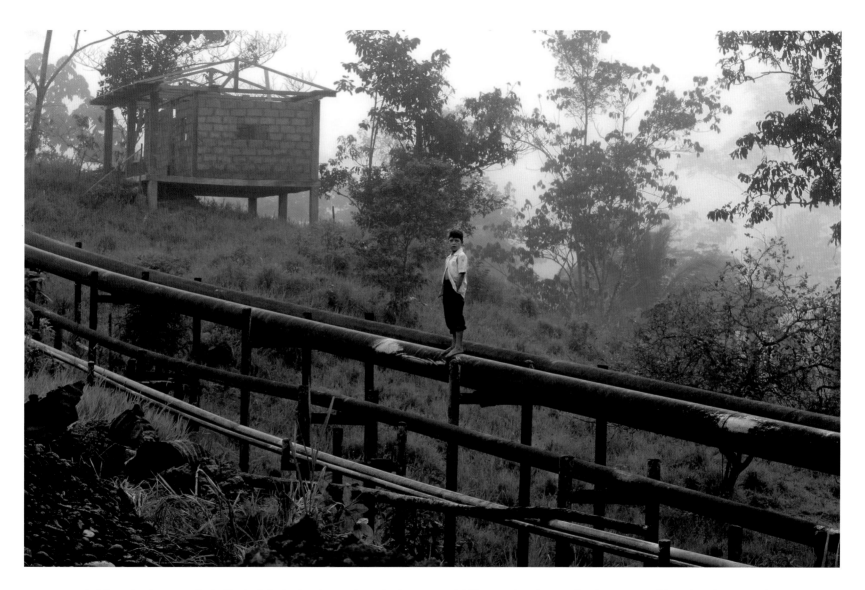

A boy stands on an oil pipeline built in the jungle near Lago Agrio.

Niño parado sobre un oleoducto construido en la selva cerca de Lago Agrio.

TEXACO IN ECUADOR

The contamination and health impacts captured in the photographs in this book resulted from fundamental design flaws in Texaco's (now Chevron) drilling and disposal practices in the Ecuadoran Amazon from 1964 to 1992. The design incorporated two substandard practices that generally were not used at the time in the United States.

1. DUMPING FORMATION WATER: Instead of following the standard industry practice of re-injecting formation water and other toxic waste generated by the oil drilling process back into the ground, Texaco dumped some 18 billion gallons of it into wetland areas near each of its 18 separation stations and 339 wells. This was extremely hazardous; the state of Texas outlawed the practice of dumping formation water in the 1930s, and Texaco itself had taken a leading industry role in re-injecting these substances in the U.S. at the same time it was dumping them in Ecuador. Formation water is saturated with life-threatening carcinogens such as benzene, toluene, xylene, cadmium, mercury, polycyclic aromatic hydrocarbons and heavy metal salts.

2. CONSTRUCTION OF HUNDREDS OF UNLINED OPEN-AIR WASTE PITS: Texaco constructed hundreds of unlined open-air pits on the jungle floor where it dumped oil sludge derived from the perforation or cleaning of its wells. These substances contain high levels of toxins, such as the carcinogen chromium 6, which were used to create pressure to dislodge rocks so the oil could be reached. Some of these pits are as large as football fields. Because these pits were unlined, the contaminants leached into the surrounding soil and groundwater and caused wide ecosystem damage. Texaco has never indicated how many pits it constructed, and it is unclear if the company even kept accurate records. A 2001 survey counted 627 such pits, but it is likely there were upwards of 1,000 built, as many were covered with dirt without cleaning out the toxins or notifying local residents.

The company also burned billions of cubic feet of gas, dumped waste crude on roads to keep the dust down, and burned oil on top of the pits, which produced a form of toxic "black rain" that contained cancer-causing dioxins.

Note: In 2001 Chevron acquired Texaco and renamed the company ChevronTexaco. In 2005, Texaco was dropped, and today the corporation is again known as Chevron.

TEXACO EN ECUADOR

La contaminación y los impactos en la salud plasmados en estas fotografías son el resultado de fallas fundamentales de diseño en las prácticas de perforación y eliminación de desechos de la compañía Texaco (actualmente Chevron) en la Amazonía entre 1964 y 1992. Se utilizaron principalmente dos prácticas que estaban por debajo de los estándares de calidad en la industria y que ya no eran usadas en los Estados Unidos en general.

1. VERTIMIENTO DE AGUAS DE FORMACIÓN: En lugar de re-inyectar las aguas de formación en el suelo, práctica estándar en la industria, Texaco derramó más de 18 mil millones de galones de aguas de formación en extensas áreas de pantanos alrededor de sus 18 estaciones de separación y 339 pozos. La no re-inyección de las aguas de formación ha sido considerada una práctica altamente peligrosa; el estado de Texas la prohibió en 1930, e irónicamente Texaco ha sido líder en la re-inyección dentro de los Estado Unidos, al mismo tiempo practicando lo contrario en Ecuador. Estas aguas de formación están saturadas con peligrosas sustancias cancerígenas como benceno, tolueno, xileno, cadmio, mercurio, hidrocarburos aromáticos policíclicos y sales de metales pesados.

2. CONSTRUCCIÓN DE CIENTOS DE PISCINAS DESCUBIERTAS: Texaco construyó estas piscinas en el suelo de la selva donde derramó el lodo derivado de las actividades de perforación y limpieza de sus pozos. Este lodo contiene altos niveles de tóxicos, como el cromo 6, usado para desplazar rocas. Estas piscinas de desechos pueden ser tan grandes como un campo de fútbol. Debido a que algunas de ellas no estaban recubiertas, a través de los años los contaminantes se filtraron en el suelo y las aguas subterráneas cercanas, causando así mucha contaminación y un gran daño al ecosistema. Texaco nunca ha dado información sobre el número exacto de piscinas construidas. En el año 2001 una inspección contó 627 de dichas piscinas, pero es muy probable que existan más de 1,000, ya que muchas de éstas fueron cubiertas con tierra sin limpiar las toxinas o notificar a los residentes.

La compañía también ha quemado miles de millones de pies cúbicos de gas, ha descargado desechos de crudo en las carreteras para disminuir el polvo y ha quemado el petróleo que hay en la superficie de estas piscinas lo cual produce una "lluvia negra" tóxica que contiene dioxinas que pueden causar cáncer.

Note: En el 2001 Chevron adquirió a Texaco y nombró la compañía ChevronTexaco. En el 2005, quitaron Texaco y hoy la compañía se conoce otra vez como Chevron.

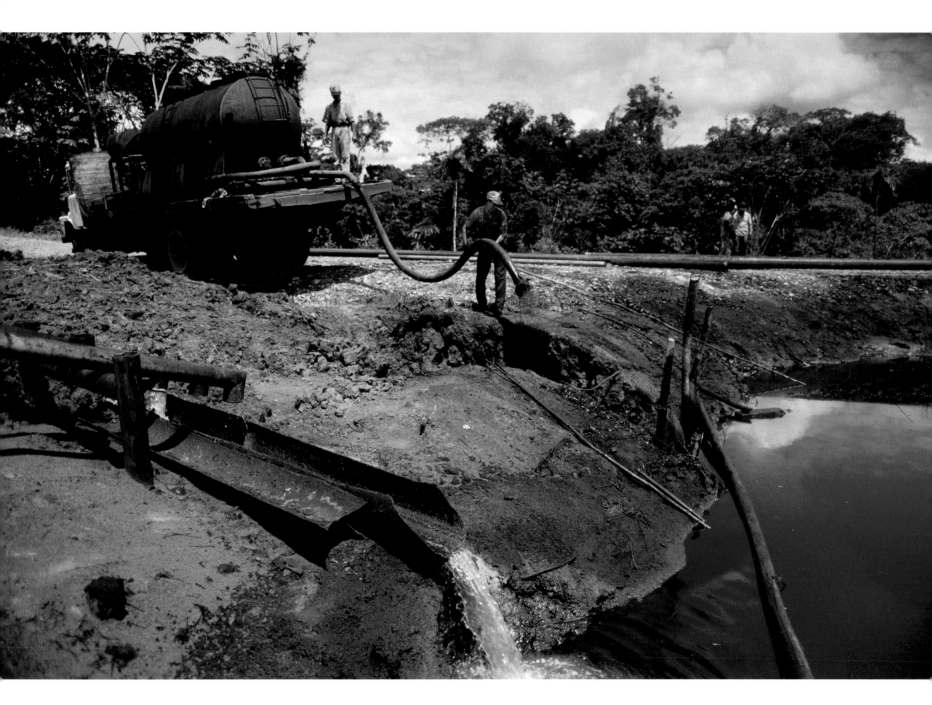

A worker siphons crude oil in 1993 from a waste pit left by Texaco near Dureno. This oil was later used to spread on roads in the area to keep the dust down.

Trabajador extrae petróleo en 1993 de una de las piscinas de desechos tóxicos dejadas por Texaco cerca de Dureno. Este petróleo era posteriormente usado para regar los caminos de la zona.

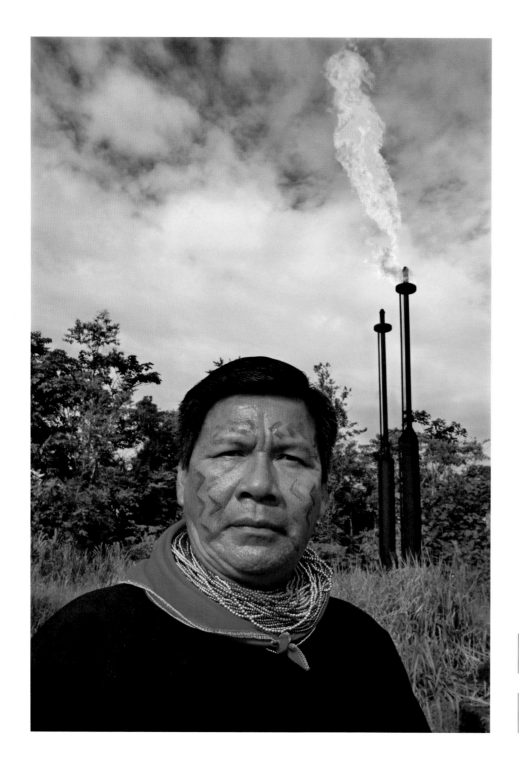

Cofan leader Emergildo Criollo stands in front of the flares of a separation plant in the Guanta oil fields. The plant was built by Texaco on Cofan ancestral territory.

Emergildo Criollo, líder de la nacionalidad Cofán, frente a las llamas de un mechero en la estación de producción del campo Guanta. La planta fue construida por Texaco en territorio ancestral Cofán.

pgs. 28-29 | *Highly toxic production water pours into a waste pit in Dureno in 1993.*
págs. 28-29 | *Agua de formación altamente tóxica es arrojada en una piscina de desechos, en Dureno en 1993.*

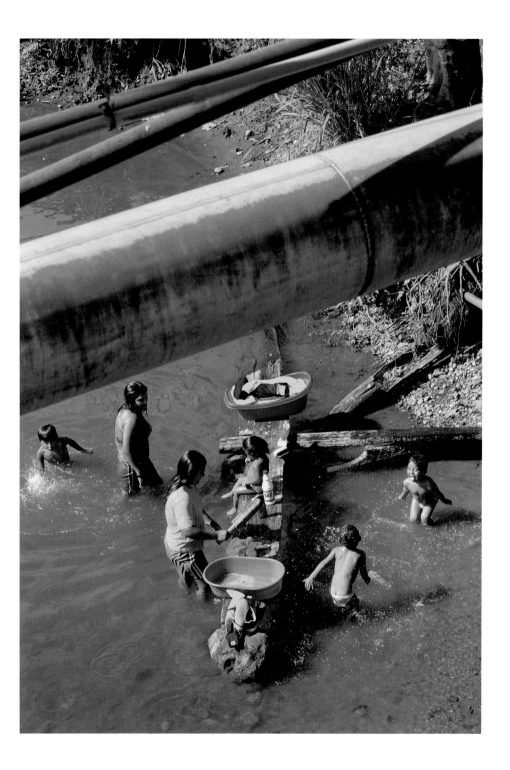

A family washes clothes and bathes under an oil pipeline in a polluted river near Lago Agrio.

Una familia lava su ropa y se baña bajo un oleoducto en un río contaminado cerca de Lago Agrio.

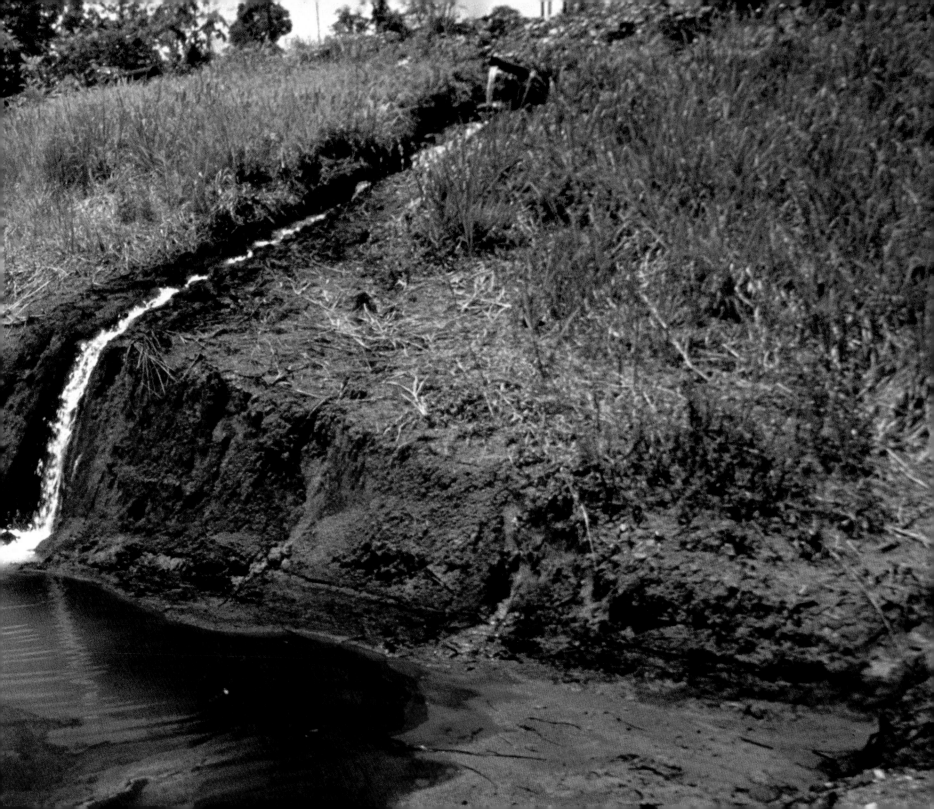

Miguel Yumbo

Texaco Auca Sur Oil Well #1 / Rumipamba
His 9-year-old son Jairo was born with a deformed hand

My name is Miguel Yumbo and I'm from the Kichwa indigenous nation. I have three sons, the middle one is Jairo. He's 9 years old. He was born with a deformed hand.

When I came to the Amazon with my family in 1982 the Via Auca [the dirt highway] was already here, and so was [Texaco Auca Sur] oil well #1, about two miles from here. Two open waste pits were also near the house.

I'm a farmer and I grow coffee and cocoa. We get our drinking water from a stream about 100 yards from the house, next to the highway, and we bathe there too. We've seen crude in the water. During the winter rains, the crude disappears, but in summer, it stays there. We push the crude aside, and gather up the clean water underneath to drink.

I couldn't be at the hospital in Coca when Jairo was born because I was working. When he was 8 days old, I went back to the hospital and talked to the doctors. They told me that the petroleum caused his hand to be like that, because we always drank water from an oil-filled stream, and because Texaco used to pass by our house spraying crude on the dirt highway.

Until three years ago, they were still spraying the roads with oil. We'd walk on that, the kids barefoot, and it would make us sick.

I took Jairo to the oil company's medical clinic, and they said that his hand had nothing to do with the oil, that it was a result of a medicine we took to stop having children. We never took any medicine, but I preferred not to say anything; I just left. The oil company people always became angry if we said anything or complained.

At school, the kids tease Jairo and laugh at him. Sometimes he wears a long-sleeved shirt to cover his hand.

The doctors told me to bring Jairo back to the hospital when he was 6, but I didn't because I've never had enough money, and now he's 9-years-old.

Miguel Yumbo

Texaco Auca Sur Pozo #1 / Rumipamba
Su hijo Jairo, 9 años, nació con la mano deformada

Me llamo Miguel Yumbo y soy de nacionalidad Kichwa. Tengo tres hijos; Edison, Jairo y Jickson. Jairo, de 9 años, tiene la mano descompuesta.

Yo llegué en 1982. Ya estaba hecha la Vía Auca [el camino de tierra] y ya había pozos [de Texaco]. El pozo #1 [Texaco Campo Auca Sur] está como a tres kilómetros de aquí. Dos piscinas estaban cerca de la casa también.

Yo soy agricultor, siembro café y cacao. Nosotros sacamos el agua de esta quebrada que está a 100 metros de la casa, por el camino. Ahí mismo nos bañamos. Hemos visto crudo en el agua. Durante el invierno, se iba, pero en tiempo de verano, se quedaba allí. Este mismo agua tomamos nosotros, hacíamos el crudo aparte, después ya apenas se queda agua limpia, así cogíamos eso.

Jairo nació en el hospital en Coca mientras yo trabajaba. Después de que nació, a los 8 días, al hablar con los mismos doctores, nos dijeron que esto había sido causado por el petróleo mismo. Nosotros siempre tomamos de la misma quebrada y en ese tiempo todavía Téxaco pasaba por aquí, regando el camino con crudo.

Hace como tres años, todavía pasaban botando petróleo. Nosotros caminábamos por aquí, más que todo los niños sin zapatos y les ha dado muchas enfermedades.

Llevé al niño a la clínica de la compañía y dije que éste podía ser un problema del petróleo. Me decían que no, que era porque nosotros habíamos hecho un tratamiento o algo para no tener hijos, pero yo no he hecho ningún tratamiento. Yo preferí no decir nada, me vine. Hemos reclamado, pero nunca nos han dicho nada, más bien se han puesto bravos.

En la escuela sus compañeros se ríen mucho de él, a veces usa manga larga para que no lo ven.

Me dijeron que debería llevarle al hospital cuando tenga 6 años, pero como no tuve plata, no lo pude llevar y ahora ya tiene 9 años.

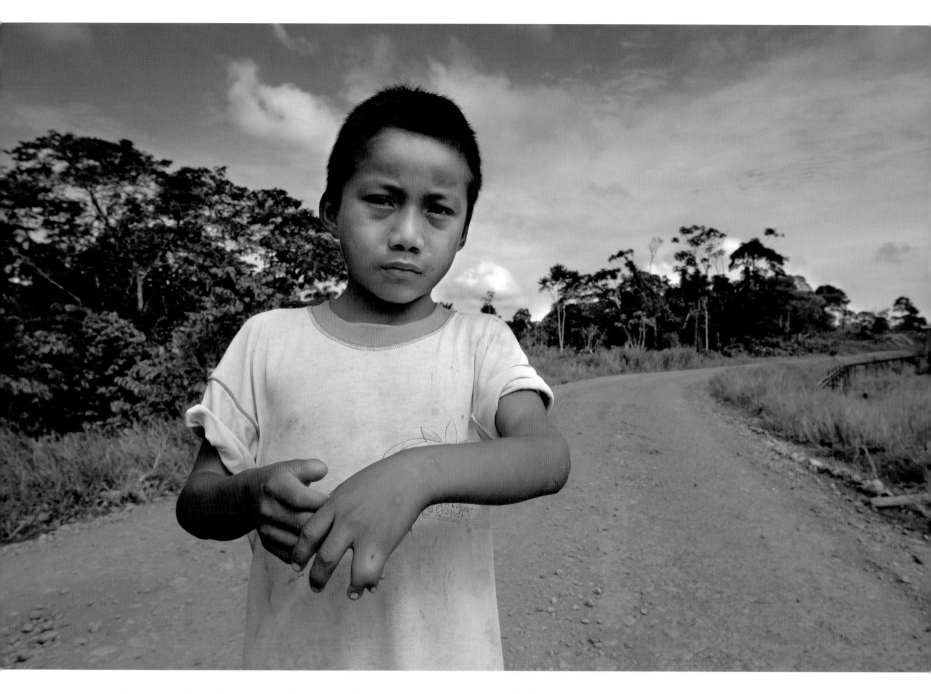

Nine-year-old Jairo Yumbo shows his deformed hand on the Via Auca in front of his home in Rumipamba.

Jairo Yumbo, de 9 años, muestra su mano deformada frente a su casa en la Vía Auca en Rumipamba.

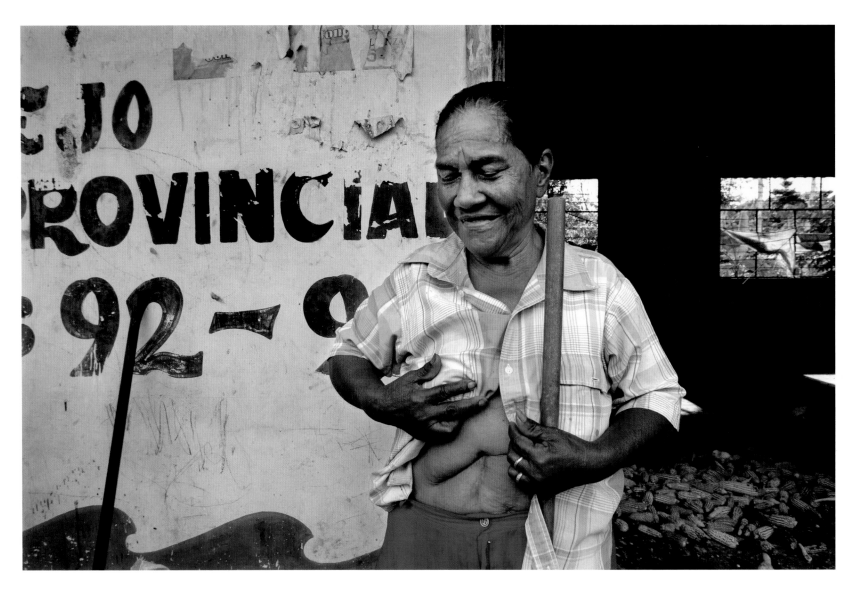

Maria Villacis shows the scars from four operations on her liver and gallbladder at her farm near Guanta Oil Well #8.

María Villacís muestra cicatrizes de cuatro operaciones al hígado y a la vesícula, en su finca cerca del pozo petrolero #8 de Guanta.

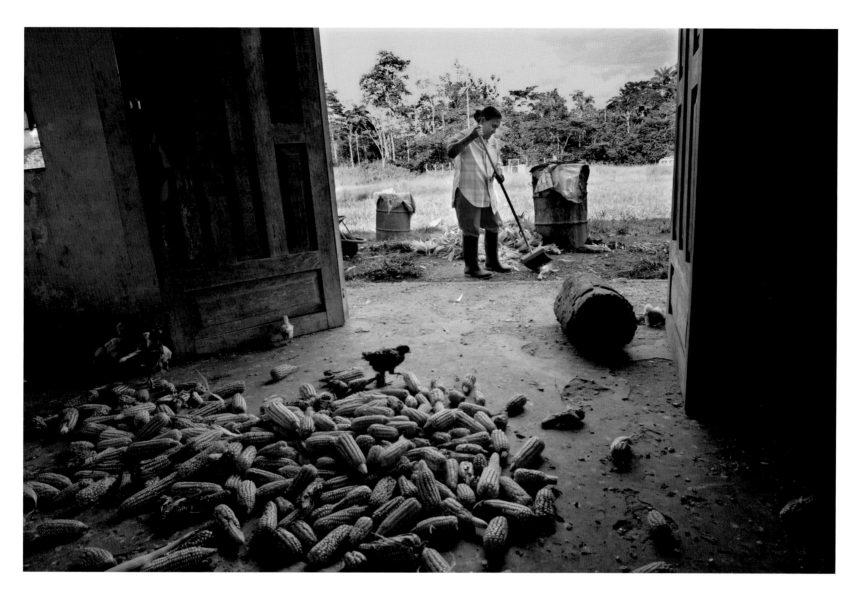

Maria Villacis sweeps in front of her barn on her farm near Guanta oil well #8. Villacis is sick from drinking contaminated water. Behind her is a covered waste pit left by Texaco.

María Villacís barre frente a su granero en su finca cerca del pozo petrolero #8 de Guanta. Villacís está enferma por tomar agua contaminada. Al fondo, una piscina de desechos tóxicos, cubierta con tierra y abandonada por Texaco.

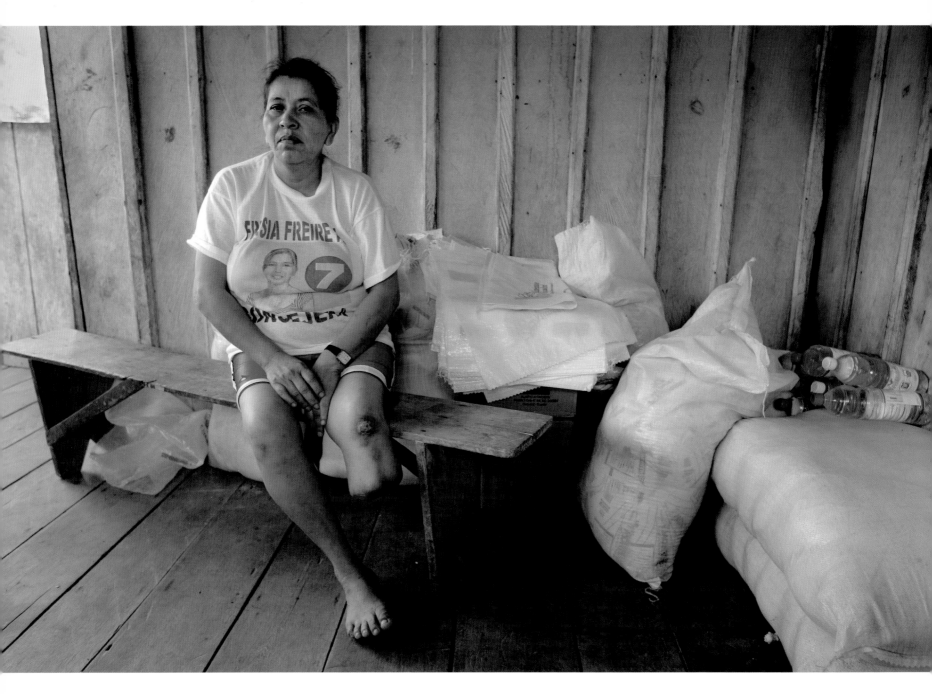

Modesta Briones in her house near Parahuaco Oil Well #2. Doctors amputated her lower leg because of a cancerous tumor.

Modesta Briones en su casa, cerca del pozo petrolero #2 de Parahuaco. Su pierna tuvo que ser amputada debido a un tumor canceroso.

Modesta Briones and Segundo Salinas

Texaco Parahuaco Oil Well #2 / Parahuaco
Cancerous tumor led to amputation of her leg

Modesta Briones: It started with a little sore on my toe, which grew a bit larger. The water near my house, where I washed clothes, was full of crude and the sore grew bigger, as if the flesh were rotting. It didn't hurt, but I couldn't stand its stink. I had a fever and chills.

Segundo Salinas, husband: In Quito they said it was a cancerous tumor, and they had to amputate her leg, or the cancer would spread throughout her body and she could die.

Modesta Briones: When the doctor told me he was cutting off my leg, I was so sick that I thought I was going to die. He amputated, and the doctor said that I should return for a checkup, but I haven't gone back because I don't have the money.

I'm having a hard time getting used to living without my foot. I can't walk with crutches. My husband, daughter and son help me, but it's a hardship for them. Now, I no longer leave the house. Since the operation, I've only left my house once, to request an I.D. card. After losing my leg, I regret moving to the Amazon, but what can one do?

Segundo Salinas: We've lived here some 30 years. We moved here looking for a better future because there was unoccupied land for sale at a good price.

Texaco had already drilled five oil wells. In those days, the oil companies didn't respect any laws. Nor did they respect us. They would say, "This is government land and we've made a deal with the government. And it doesn't include you, so leave." They would arrive, decide they wanted to drill somewhere, and then drill. They brought in machines and crushed your crops.

There are three toxic waste pits near my house, so many animals died. When my horses and chickens fell in, I pulled them out, but they stopped eating and died.

Some of the oil wells here have flares that burn off gas. The smoke rises, and when the rains come, black rain with a rusty smell falls back to earth, contaminating the land and the water.

Modesta Briones y Segundo Salinas

Texaco Parahuaco Pozo #2 / Parahuaco
Pierna amputada por tumor canceroso

Modesta Briones: A mí me salió un granito en el dedo del pie y así se puso un poquito más grande. El agua donde lavaba estaba con crudo y se fue haciendo más grande como si se fuera pudriendo la carne. No tenía dolores, pero ya no soportaba el mal olor. Tenía fiebre y escalofríos.

Segundo Salinas Jiménez, esposo: En Quito nos dijeron que era una llaga cancerosa y tenían que amputarle la pierna porque si no, el cáncer aumentaría por todo el cuerpo y podía perder la vida.

Modesta Briones: Cuando el doctor dijo que me tenían que cortar la pierna, yo ya estaba bien mal, parecía que me iba a morir. Después de la operación, el médico me dijo que tengo que regresar para un chequeo pero no he ido todavía por la falta de dinero.

No estoy acostumbrada a estar así sin pierna. No puedo caminar con muletas. Mi niña, mi marido y mi hijo me ayudan. Ellos están con pena.

No salgo de la casa, sólo he salido una vez desde la operación para sacar la cédula. Sí, me arrepiento (de venir al oriente), pero ¿qué voy a hacer?

Segundo Salinas: Hace 30 años vinimos aquí buscando el futuro, pensando que aquí había bastante tierra baldía y a buen precio.

Texaco hicieron Parahuaco 2, 3, 5, 7 y 8. En ese tiempo las compañías no tenían ley, ni respetaban a nadie. En esa época, los petroleros eran abusivos. Sólo decían: "Hemos hecho un compromiso con el estado, que nada tiene que ver con ustedes, váyanse." Cuando ellos vinieron, decidieron, aquí vamos a perforar y ahí perforaron. Si alguien tenía sembrados en ese lugar, lo que hacían era meter la máquina y dañaban las plantas.

Aquí hay tres piscinas cerca de mi casa y los animales morían. Los sacaban de las piscinas los caballos y las gallinas, pero igual se morían. Empezaron a ponerse flacos, dejaron de comer y se murieron.

Aquí en los pozos petroleros algunos tienen mecheros y de estos mecheros sale gas. Muchas veces la lluvia viene con el color negro y un olor a alumbre, óxido. Cuando vienen las lluvias, baja toda la contaminación sobre el suelo, se está contaminado todo.

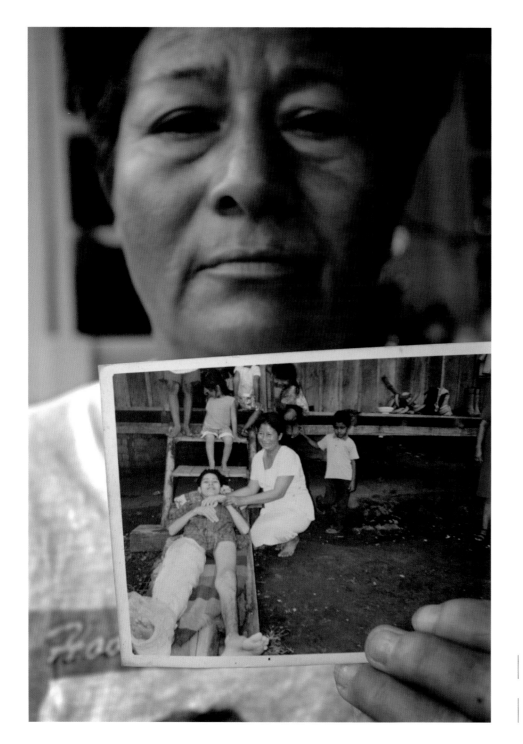

Dolores Morales and son Jose

Sacha

Mother of Pedro, who died of cancer, and Jose, who has leukemia

Dolores Morales: We lived in a house about 20 yards away from an oil well. Another Texaco oil well was upstream from where we got our drinking water, and the water was usually oily with a yellowish foam.

I had 11 children. I lost Pedro when he was 19. The first sign of his sickness was when he broke his leg. He never stood up after that. He had three cancerous tumors: in his lungs, liver, and his leg. He only lived 10 months longer.

He really suffered. He begged the doctors to amputate his leg, but it was too late, the cancer had spread to the rest of his body. He was young; he had a girlfriend. He didn't want to die.

Afterwards we were all sad. We still feel very bad.

Now, my 15-year-old son has leukemia. He's receiving treatment. There are times when he has relapses, when he doesn't want to eat, when his bones ache. Right now he's in remission, but as he matures, it could be dangerous; the leukemia could return.

Jose: I first felt sick when I was 4 years old; my bones hurt. They say I have leukemia. When I'm sick, my bones ache, I fall down a lot, and I feel sad. I have to go to Quito every 6 weeks for a checkup. But I haven't gone recently because my mother doesn't have any money. I'm afraid that I'm going to have more problems in the future.

Dolores Morales, at her home in Sacha, holds a photo of her 19-year-old son Pedro, who died of cancerous tumors.

Dolores Morales en su casa en Sacha sostiene una fotografía de su hijo Pedro de 19 años, quien falleció de tumores cancerosos.

Dolores Morales e hijo José

Madre de Pedro quien murió de cáncer y de José, que tiene leucemia

Dolores Morales: Había un pozo a 20 metros de la casa. Y justo donde nosotros cogíamos agua, el pozo 83 está arriba y esta agua sale con aceite con una nata amarilla.

Tenía 11 hijos. El que falleció se llamaba Pedro, de 19 años. El primer síntoma fue por una quebradura de pierna. De allá no pudo levantarse. Pedro tenía 3 tumores cancerosos, en los pulmones, el hígado y la pierna. Sólo duró 10 meses no más. Falleció.

Él sufrió más, porque suplicaba a gritos a los doctores que le cortaran la pierna, pero ya era imposible porque el cáncer ya había contaminado todo el cuerpo. Era joven, tenía novia. Él no quería morirse, decía que quería seguir viviendo.

Después, todos tristes... Lo sentimos mucho ya...

Ahora mi hijo que tiene 15 años sufre de leucemia. Él sigue en tratamiento. Hay tiempos cuando él está decaído, no quiere comer, le duelen los huesos. Dicen que por ahora está libre de este cáncer, pero que tiene toda la posibilidad de venirse, o sea, el desarrollo es peligroso para él.

José: La primera vez que me sentí mal era que me dolían los huesos. Tenía 4 años. Cuando estoy enfermo, me duelen los huesos, me caigo y estoy triste. Tengo que ir a Quito para el chequeo médico cada seis semanas. Pero no he salido porque mi mamá no tenía dinero. Me da miedo que pueda tener problemas en el futuro.

Dolores Morales with her 15-year-old son Jose, who suffers from leukemia, at their home in Sacha.

Dolores Morales en su casa en Sacha junto a su hijo José, de 15 años, quien padece de leucemia.

Juana Apolo

San Francisco, Via Auca
Her father, brother and sister died of cancer

I've lived here in the Amazon for 20 years, and I am a cook at the San Francisco oil camp. My father, Manuel Ignacio Apolo, died in 1992 of skin cancer; he was 68. His first symptom was that he had a little sore below his eye. He had two operations and lost his eyesight. The doctors said that the cancer had spread, and when it went into his brain, he would die.

When he got sick, we had a family meeting with all 10 of us brothers and sisters, and we chipped in to pay for his treatments.

He was a farmer and grew corn, rice, peanuts, yucca and plantains. Afterwards, when he was sick, he couldn't work.

My sister, Carmen Apolo, died when she was 44. She had a tumor, and the doctor said it was uterine cancer. They operated, but she didn't last a year. She was a single mother and the eldest of all of us.

My brother, Saul Apolo, died of stomach cancer when he was 49. They operated, but the tumor was too big. It must have been the contamination that killed him.

Amada Armijos, sister-in-law of Juana, wife of Saul

My husband, Saul Apolo Ramírez, and I lived near four Texaco wells, all upriver from our house. About a mile away is a big [Texaco] waste pit. Our family drank from this river and washed our clothes in it. Sometimes we'd see oil in the river, but they told us that it wasn't polluted.

My husband died of stomach cancer after suffering for almost four years. When he grew thin, we went to Solca Cancer Hospital in Quito, but they told us he couldn't be saved. He was in the last stage. (*Crying*) This disease has been horrible. We came home to the Amazon, and 15 days later he died.

I don't know why there's so much cancer around here nowadays; maybe it's the contamination.

Juana Apolo

San Francisco, Vía Auca
Su padre, hermano y hermana murieron de cáncer

Tengo 20 años de vivir en el oriente y soy cocinera del campamento en San Francisco. Mi papá, Manuel Apolo, 68, murió en 1992 de cáncer de la piel. El primer síntoma de la enfermedad fue un granito que tenía bajo el ojo.

Tuvo dos operaciones y le sacaron la vista. El cáncer ya estaba para adentro y el doctor dijo que una vez que le llegara al cerebro, se iba a morir.

Nos reunimos todos los varones y mujeres. Somos 10 y ayudabamos con dinero para los remedios.

Era agricultor. Sembraba maíz, arroz, maní, yuca, plátano. Pero ya después, no podía trabajar.

Mi hermana, Carmen Apolo, también murió cuando tenía 44 años. Tenía un tumor y el doctor dijo que era cáncer de útero. La operaron, pero no hubiera podido aguantar ni un año. Era madre soltera y la mayor de todos.

Mi hermano, Saúl Apolo, se murió de cáncer de estómago cuando tenía 49 años. Lo operaron, pero el tumor estaba demasiado grande. Sería la contaminación.

Amada Armijos, 48 años, cuñada de Juana, esposa de Saúl

Mi marido y yo vivíamos cerca de cuatro pozos del Texaco, todos río arriba de nuestra casa. La piscina [de Texaco] está como a un kilómetro y medio de aquí. Cogíamos el agua de allí, allí nos lavábamos y tomábamos de esa agua. Sí, a veces había crudo en el rió, pero dicen que no tenía contaminación.

Mi marido se murió de cáncer, tenía cáncer en la boca del estómago. Sufrió casi cuatro años. Al final cuando estaba mal, se puso delgado. Ahí fue cuando nos fuimos para Solca pero decían que ya no tenía cura, estaba en la última etapa. (*Llorando*) Esta enfermedad había sido terrible. Luego nos vinimos acá al oriente y como a los 15 días, falleció.

No sé porque pero todo es cáncer ahora en este tiempo. Será la contaminación.

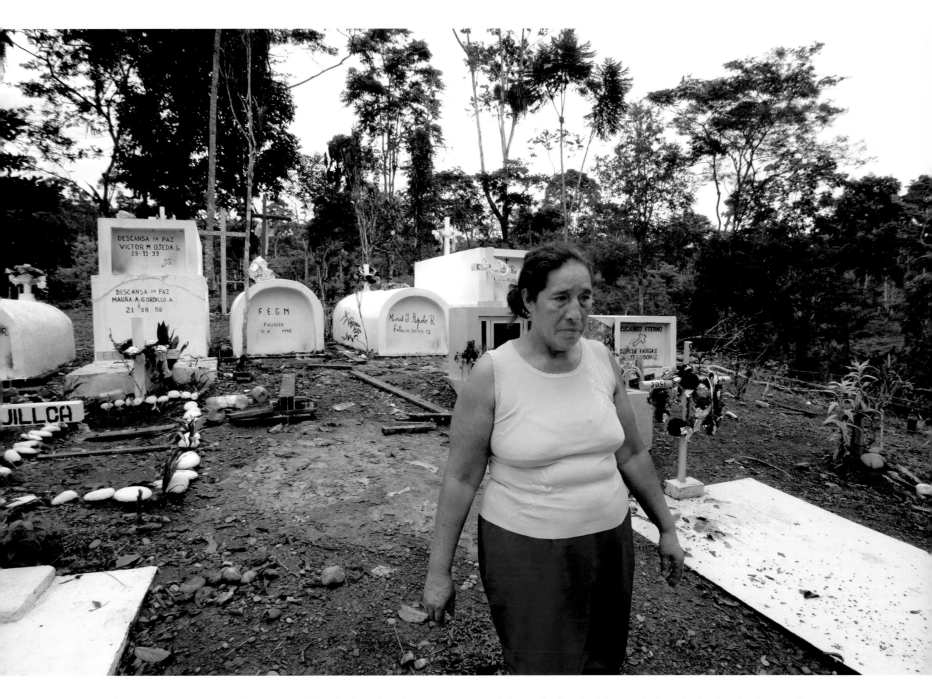

Juana Apolo walks out of a cemetery in La Andina where her father, brother and sister are buried, all of whom died of cancer.

Juana Apolo sale del cementerio en La Andina donde su padre, hermano y hermana fueron enterrados. Todos ellos murieron de cáncer.

HEALTH ISSUES IN THE AMAZON

The billions of gallons of oil waste dumped by Texaco in Ecuador's rainforest contained some of the most potent carcinogens known to humans (see page 24). Much of that toxic cocktail remains to this day and continues to contaminate water, plant, animal and human life. The "Yana Curi" Report ("Black Gold" in Kichwa) is an extensive study on the effects of this contamination conducted by Doctors Miguel San Sebastian and Juan Antonio Cordoba, in collaboration with the Department of Tropical Medicine and Hygiene at the University of London.

According to the report, which focused on the village of San Carlos where Texaco built more than 30 wells, oil-related carcinogens enter the body from ingesting water and food, absorption through the skin, and inhalation of oil and its gases. The study states that the water used daily by people in the region for drinking, bathing and cooking contained concentrations of these toxic substances nearly 150 times greater than is considered safe.

The report found that the residents of San Carlos are 2.3 times more at risk for cancer than residents in Quito. The male population's risk of developing bile duct cancer is 18 times higher, and for liver cancer and melanoma it is 15 times higher; for stomach cancer it is 4.6 times, and 2.6 times higher for leukemia. For women, the risk of lymphoma is 6.7 times higher and cervical cancer is 2.3 times higher. Other studies have shown significantly elevated rates of birth defects, childhood leukemia and spontaneous abortions in communities exposed to contamination than elsewhere in the Amazon region where there is no petroleum exploitation.

A mother holds her 10-month old daughter with a skin rash likely caused by bathing in oil-polluted water in Rumipamba in 1993.

Madre sostiene a su hija de 10 meses, con un sarpullido probablemente causado por el baño en agua contaminada con petróleo en Rumipamba en 1993.

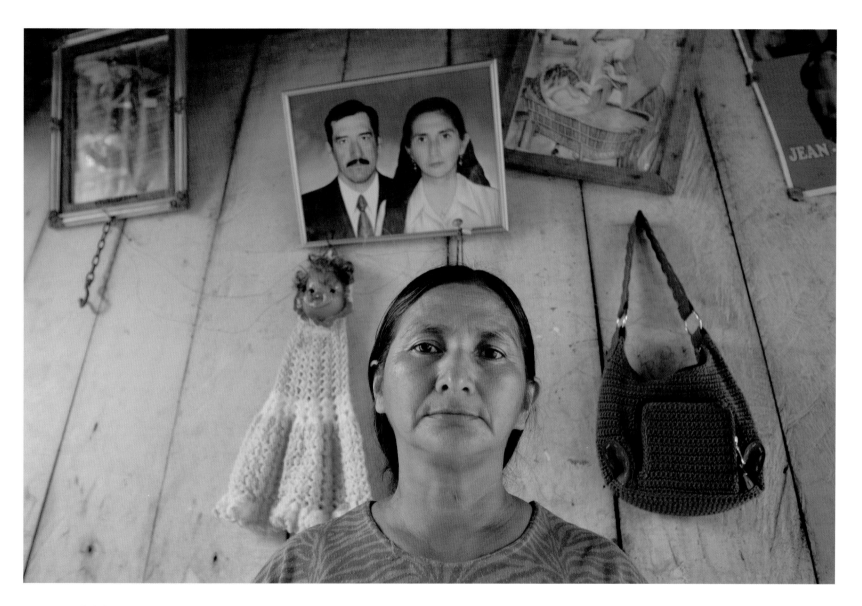

At her home in La Andina, Amanda Armijos, sister-in-law of Juana Apolo, stands in front of a photo of herself and husband Saul Apolo, who died of stomach cancer.

En su casa en La Andina, Amanda Armijos, cuñada de Juana Apolo, en frente de una fotografía de ella con su esposo Saúl Apolo, quien falleció de cáncer de estómago.

REPUBLICA DEL ECUADOR
DIRECCION GENERAL DE REGISTRO CIVIL
IDENTIFICACION Y CEDULACION For No. 005-RCN

CERTIFICADO SIMPLE GRATUITA PARA LA INHUMACION Y SEPULTURA

CERTIFICO: Que en el Registro de Defunciones del año 2,002 en el tomo 1 pagina 30
número de acta 30 se halla inscrita la defunción de EUGENIO SAUL APOLO RAMIREZ
Numero de Cédula 070108884-1
de nacionalidad ECUATORIANO de 49 años de edad, estado civil CASADO
de profesión AGRICULTOR fallecido el dia 22 del mes MARZO
2,002 , a las 14;30 horas de la TARDE a causa CANCER
DE ESTOMAGO según el certificado del Dr. RUBEN RIVADENE... Madre JOVIN...
Nombres de los padres del fallecido: Padre MANUEL APOLO
ORELLANA Provincia de
OFICINA DEL REGISTRO CIVIL DE Fco. de ORELLANA a 26 de MARZO

Jefe de Registro Civil

At her home in La Andina, Amanda Armijos holds the death certificate of her husband Saul Apolo which lists stomach cancer as the cause of death.

En su casa en La Andina, Amanda Armijos sostiene el certificado de defunción de su esposo Saúl Apolo, en el que se lista cáncer de estómago como causante de la muerte.

PROBLEMAS DE SALUD EN LA AMAZONÍA

Los miles de millones de galones de desechos de petróleo derramados por Texaco en la selva Amazónica del Ecuador contienen algunas de las sustancias más cancerígenas conocidas por los seres humanos (pág. 24). Estos desechos continúan contaminando agua, plantas, animales y humanos. El Informe Yana Curi es un extenso estudio de los efectos de esta contaminación, realizado por los doctores Miguel San Sebastián y Juan Antonio Córdoba, junto con el Departamento de Medicina Tropical e Higiene de la Universidad de Londres.

Según este informe, centrado en la población de San Carlos donde Texaco construyó más de 30 pozos, las sustancias cancerígenas ingresan al organismo a través del agua y los alimentos, son absorbidas por la piel e inhaladas del petróleo y sus gases. El informe establece además que el agua usada diariamente por las personas de la región para beber, cocinar y bañarse contiene concentraciones de toxinas 150 veces mayores a las consideradas como seguras.

El informe encontró también que los habitantes de San Carlos tienen 2.3 veces más riesgo de desarrollar cáncer, en comparación con las tasas de cáncer en Quito. En los hombres, el riesgo de cáncer del conducto biliar es 18 veces más alto; el de cáncer de hígado y melanoma es 15 veces más elevado; el de cáncer de estómago es 4.6 veces más alto y el de leucemia es 2.6 veces mayor. En las mujeres, el riesgo de linfoma es 6.7 veces más alto y el de cáncer cervical es 2.3 veces más. Otros estudios han mostrado tasas más altas de defectos de nacimiento, leucemia infantil y abortos espontáneos en las comunidades expuestas a la contaminación petrolera, contrariamente a lo que ocurre en otras zonas donde no ha habido explotación petrolera.

Flor Valarezo with her daughter Liliana Cecilia in Sacha, shows the skin problems on her leg which doctors say could be cancer.

Flor Valarezo con su hija Liliana Cecilia en Sacha, muestra los problemas cutáneos de su pierna, que los médicos dicen podría ser cáncer.

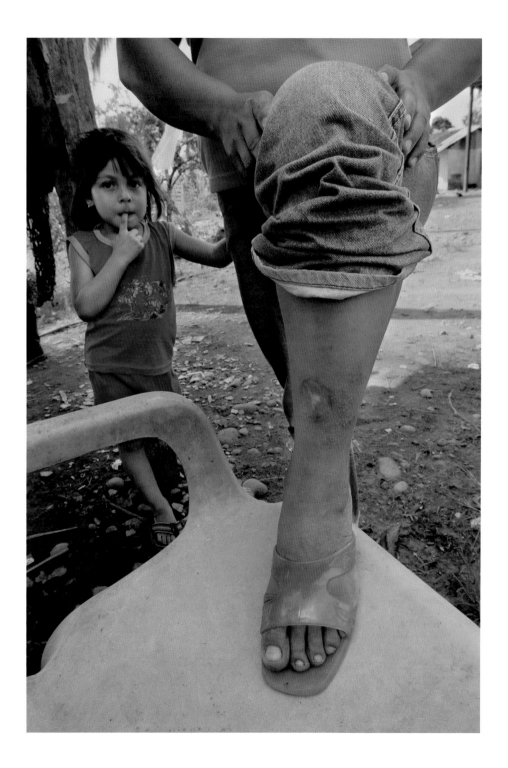

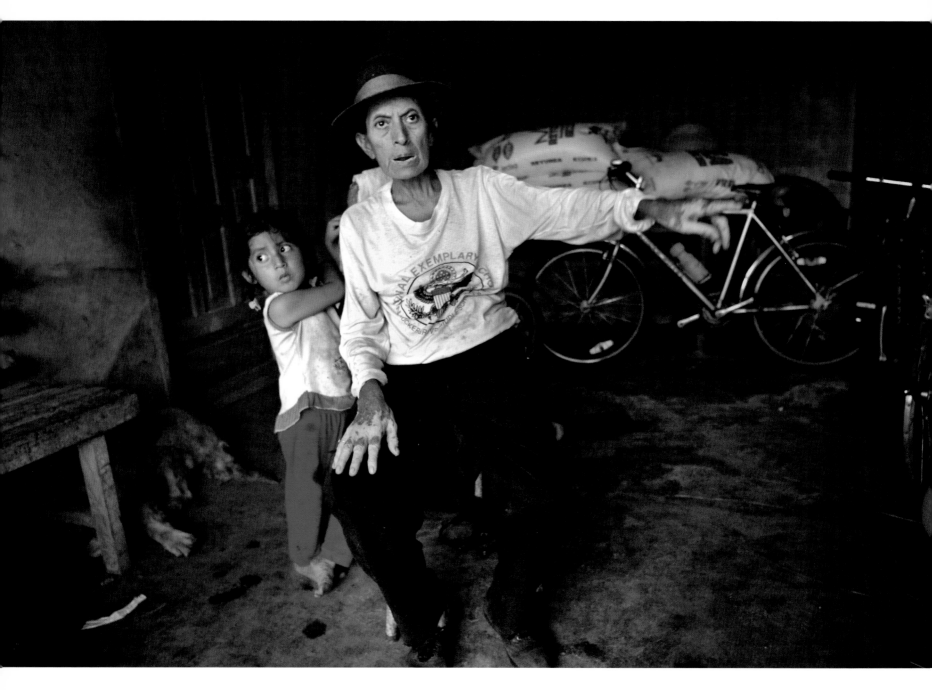

Uterine cancer victim Rosana Sisalima with her granddaughter at their home in San Carlos in 2004. Rosana died in 2006.

Rosana Sisalima, víctima de cáncer de útero, junto con su nieta en su casa en San Carlos en 2004. Rosana murió en el 2006.

Rosana Sisalima

San Carlos

Uterine cancer victim; husband died of stomach cancer

Our house is located between a [Texaco] toxic waste pit and an oil spill. There are three [Texaco] oil wells nearby. A big oil spill had just occurred when we moved here. The oil company burned the oil and there was smoke everywhere. The former owner of this farm died of stomach cancer three years after he sold it to us.

I've lived here for 22 years. I came with my husband and 10 children from Loja. We bought this farm which is surrounded by two [Texaco] open waste pits. So many animals fell in; chickens, dogs, watusas, rabbits. We pulled them out and cleaned them, but they were covered with sludge, and died anyway.

We pleaded with the oil company to clean the pits, and they finally showed up, only to cover the pits with dirt. But in heavy rainstorms, the pits overflow and waste runs into the streams, contaminating them.

We bathed in the river and got our drinking water there too. We pushed the crude aside and dipped in our buckets, and we ate fish from that river. We never realized the river was contaminated.

I was diagnosed with uterine cancer in 1988. I went to Solca [the cancer hospital] and stayed there two months while they burned off the cancer until the doctor told me I was better.

My husband died of stomach cancer. He grew coffee, and worked almost until the day he died. One day he stopped eating. We went to the doctors and they operated but he had a malignant tumor and the cancer had already spread throughout his body. He was 64, so young.

I had a hysterectomy, then in 2004 gallbladder surgery. I had stomach-aches, vomiting and diarrhea for over a year. I've been seriously ill. (*Crying*)

My children have helped with the medical costs. We sold our cattle, and we had to sell half our farm, but I still don't know how we'll pay the rest.

ROSANA SISALIMA DIED IN MAY 2006.

Rosana Sisalima

San Carlos

Tenía cáncer de matriz; su marido murió de cáncer de estómago

La casa está entre una piscina [de Texaco] y un derrame. La casa tiene tres pozos de petróleo [de Texaco] cerca. Un derrame del oleoducto recién había sucedido cuando nosotros llegamos, quemaron el petróleo derramado y había humo por todos lados. El dueño que antes tenía la finca se murió de cáncer de estómago; se fue y se murió tres años más tarde.

Tengo 22 años de vivir aquí. Vine con mi esposo y con todos mis 10 hijos. Vine de Loja y compramos esta finca. Yo estaba rodeado de dos piscinas abiertas [de Texaco]. La piscina estaba abierta, allí murieron gallinas, perros, watusas, conejos; algunos de los perros salían, pero cubiertos de crudo. Las gallinas que lográbamos sacar, no valían nada y para que limpiarlas si se morían.

Después de mucho rogar, finalmente vinieron a limpiar, o más bien a tapar con tierra. Pero cuando había lluvias muy fuertes, las piscinas se llenaban y se derramaban al río, contaminándolo.

Cuando nos bañábamos en el río, usábamos el balde para recoger agua y para quitar el crudo de la superficie. Pescábamos de este río para comer y tomábamos el agua sin saber que estaba contaminada.

Me detectaron cáncer in 1988, cáncer de matriz. Estuve en tratamiento en Solca durante dos meses, hasta que el doctor dijo que ya estaba bien.

Mi marido se murió de cáncer de estómago. Trabajaba cultivando café, hasta poco antes de morir. Un día ya no podía comer nada. Lo operaron, pero el tumor que tenía era maligno y ya el cáncer estaba en todo el cuerpo. Era muy joven cuando murió, tenía 64 años.

Después, me operaron del útero, me lo sacaron. En el 2004 me operaron de la vesícula. Tenía diarrea, dolor de estómago y vómito, así pasó como un año. Me sentí mal, grave. (*Llorando*)

Tenía la ayuda de mis hijos con los gastos. Vendimos ganado y tuve que vender la mitad de la finca para ayudar a cubrir los gastos. Ya no había cómo. ¿Cómo pagar?

ROSANA SISALIMA MURIÓ EN MAYO DEL 2006.

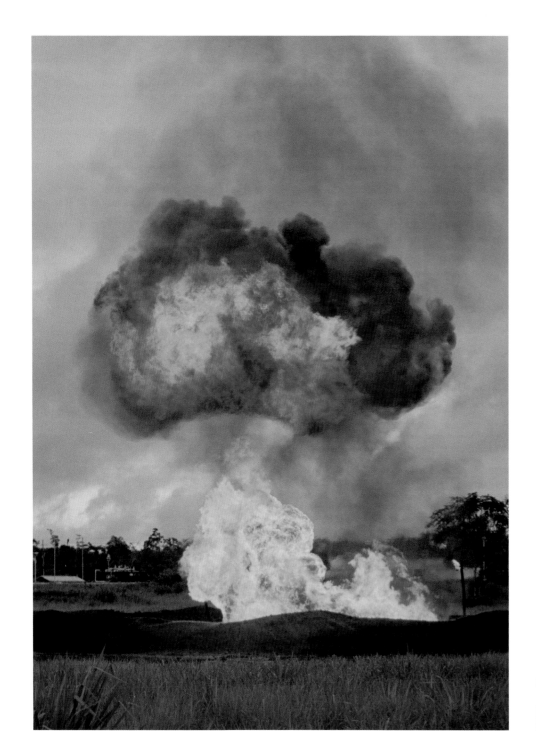

Oil waste pit fire in Shushufindi in 1993.

Fuego en la piscina de desechos tóxicos de petróleo en Shushufindi en 1993.

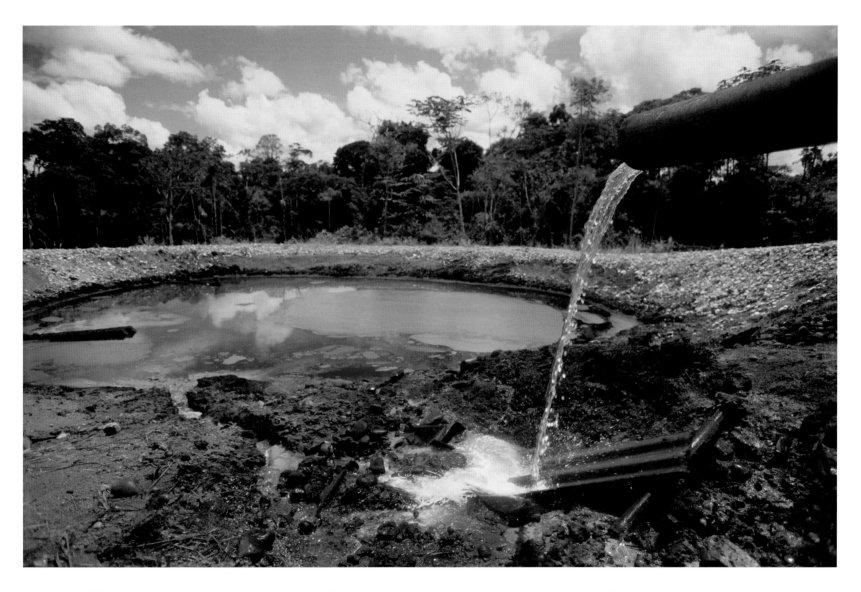

Highly toxic formation water pours into a waste pit near Dureno in 1993.

Agua de formación altamente tóxica es arrojada en una piscina de desechos, cerca de Dureno en 1993.

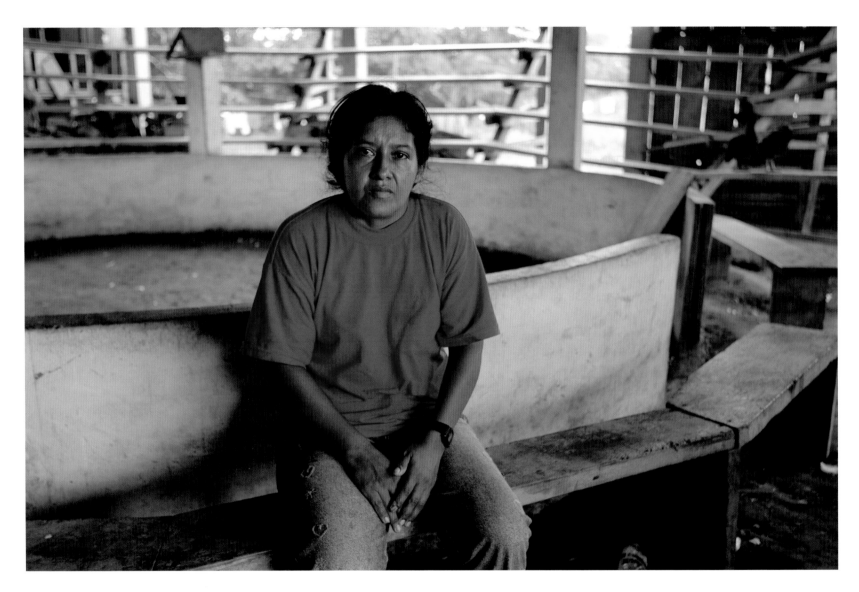

Uterine cancer victim Maria Garofalo sits outside her home in San Carlos.

María Garófalo, víctima de cáncer uterino, sentada fuera de su casa en San Carlos.

María Garófalo
San Carlos
Uterine cancer

The [Texaco] waste pits were upriver, and we drank water downriver. After bathing, our skin was covered with crude. I went to the oil companies, and they said this wouldn't affect me; that the reason I had cancer was because I didn't have good personal hygiene. If I could say something to the oil companies, I'd tell them not to contaminate the land because they are killing people, making people suffer with this contamination. (*Crying*) I have six children, and it's very sad for me to think that maybe my children will lose their mother.

SINCE THIS INTERVIEW, DOCTORS HAVE DIAGNOSED GAROFALO'S HUSBAND LUIS YAÑEZ WITH STOMACH CANCER AND HER DAUGHTER SILVIA WITH LIVER CANCER.

Cáncer de útero

Las piscinas [de Texaco] estában río arriba y cogíamos el agua más abajo. Después de bañarnos nuestra piel estaba cubierta de crudo. Me presenté a una oficina y ahí me dijeron que eso no afectaba… que era a lo mejor un descuido de mi persona, por eso yo sufría de cáncer. Yo les pediría a las compañías, pues, que no contaminen la tierra, porque están matando a mucha gente y haciendo sufrir a cuanta gente con esta contaminación. (*Llorando*) Tengo seis niños, para mí es duro y triste ponerme a pensar que a lo mejor mis hijos se quedarán sin madre.

DESDE QUE SE REALIZÓ ESTA ENTREVISTA, LOS MÉDICOS DE-TECTARON CÁNCER DE ESTÓMAGO A LUIS YAÑEZ, ESPOSO DE MARÍA GARÓFALO Y CÁNCER DE HÍGADO A SU HIJA SILVIA.

A mother and son are joined by oil workers as they walk on a road covered with crude oil outside the town of Shushufindi.

Una mujer y su hijo son acompañados por trabajadores de las petroleras mientras caminan por una vía cubierta con crudo en las afueras de Shushufindi.

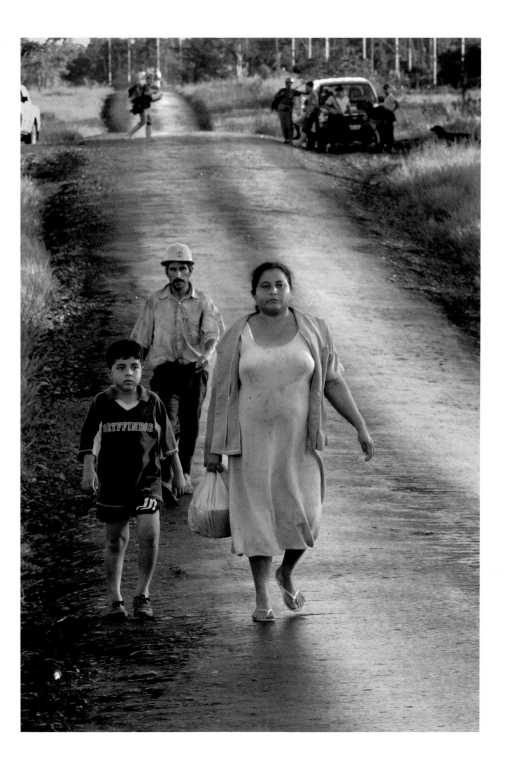

Miguel Mashumar and Maria Antuash

Texaco Auca Oil Field / Vía Auca mile 28
Their daughters died of tuberculosis and a liver infection

Miguel Mashumar: I am from the Shuar indigenous nation. I came here in 1978, looking for a better life. We had 8 children but our 2 daughters died.

When I arrived, Texaco had already drilled [Auca Sur] oil well #12 along with its open waste pit. The separation station was about 100 yards from my house. Each oil well had its waste pit and when Texaco left the country the pits were left uncovered. In 1994, they sent someone to remediate them, and they covered the waste pits with dirt.

To cut down on the dust, Texaco used to spray oil on the dirt road, then scrape it with big machines, and the road was then like asphalt. But when the sun shone, the road began to break apart, and oil bubbled up, and when it rained, oil washed out of it.

The waste pits used to have flares [that burned off gas]. They were so loud that you couldn't hear anything. They sounded like they were going to explode, and you couldn't sleep at night.

Maria Antuash: Back then, there were no laws. The smoke came into our house. They say that the burning gas that my daughter breathed could have caused her illness.

Miguel Mashumar: The stream was 50 meters from our house and chemicals were dumped into it. Oh, it stank! The water ran like a natural stream, but it was warm toxic waste water [formation water]. We had headaches, dizziness, stomachaches. And there was nowhere to make a complaint, no institution, no agency, no one to turn to.

Our children loved to fish and swim in the river. They came home covered in crude. We fried the fish they caught and the fish tasted like diesel.

Our daughter Maria married, had 2 children, separated, and then resumed studying. After her second year, she got sick, and never recovered. She was 24 years old and had tuberculosis. Now we're raising her children.

Our other daughter, Rosa, died quickly, in 15 days. She couldn't breathe, her liver hurt. She had a fever, and a headache. We took her to the doctors but the medicine they gave her made her worse. She died two days later. She was 12.

Miguel Mashumar y María Antuash

Texaco Campo Auca / Vía Auca km 42
Sus hijas murieron de tuberculosis e infección en el hígado

Miguel Mashumar: Soy de nacionalidad Shuar. Vine en 1978 para mejorar mi situación económica. Tengo 8 hijos, 6 niños y 2 niñas que murieron aquí.

Cuando llegué, ya estaba el pozo 12 [Auca Sur] con su piscina de Texaco. La estación que ya estaba funcionando, quedaba a 100 metros de la casa. Texaco, en cada pozo dejaba piscinas y cuando salió del Ecuador, dejó las piscinas abiertas, sin tapar. En 1994, mandaron a remediar, cubrieron las piscinas con tierra y así las dejaron.

Antes, para no hacer tanto polvo y baches, Texaco regaba el crudo en el suelo, después pasaba las máquinas y quedaba como si fuera asfalto. Pero cuando hacía sol, el crudo se empezó a deshacer y se empezó a desmenuzar, después cuando venía la lluvia, lo lavaba y botaba petróleo.

Cuando llegué aquí, esas piscinas ya estaban con mecheros. No se podía oír nada, parecía que iba a reventar a veces. Uno no podía dormir.

María Antuash: En ese tiempo no había control, había incendios y esa humareda se entraba a la casa. Dicen que la quema de gas que mi hija respiraba puede ser la causa de la enfermedad.

Miguel Mashumar: El estero está a 50 metros de la casa, allá botaron todo el químico, no se podía ni estar, qué pestilencia! El agua corría como si fuera natural, crudo con aguas de formación, pero era caliente. Teníamos dolor de cabeza, mareos, dolor de estómago. No había donde discutir, denunciar, no había ninguna institución que nos amparara.

Los niños traviesos que les gusta pescar, entraban y a veces llegaban manchados de crudo y el pescado que cogían, cuando lo hacían freír, tenía mal sabor y olor a diesel.

María se casó, tuvo 2 hijos, se separó de su esposo, empezó el colegio, pasó el segundo curso y cayó enferma para nunca curarse. Tenía 24 años. Dicen que tenía tuberculosis. Ahora estamos cuidando a los hijos.

La otra hija, a los 15 días se murió rapido. No podía respirar, le dolía el hígado, tenía fiebre, dolor de cabeza. Fuimos al Seguro Campesino, le hicieron unos análisis, pero ésta medicina no le ayudó, la puso peor y a los dos días se me murió. Ella tenía 12 años.

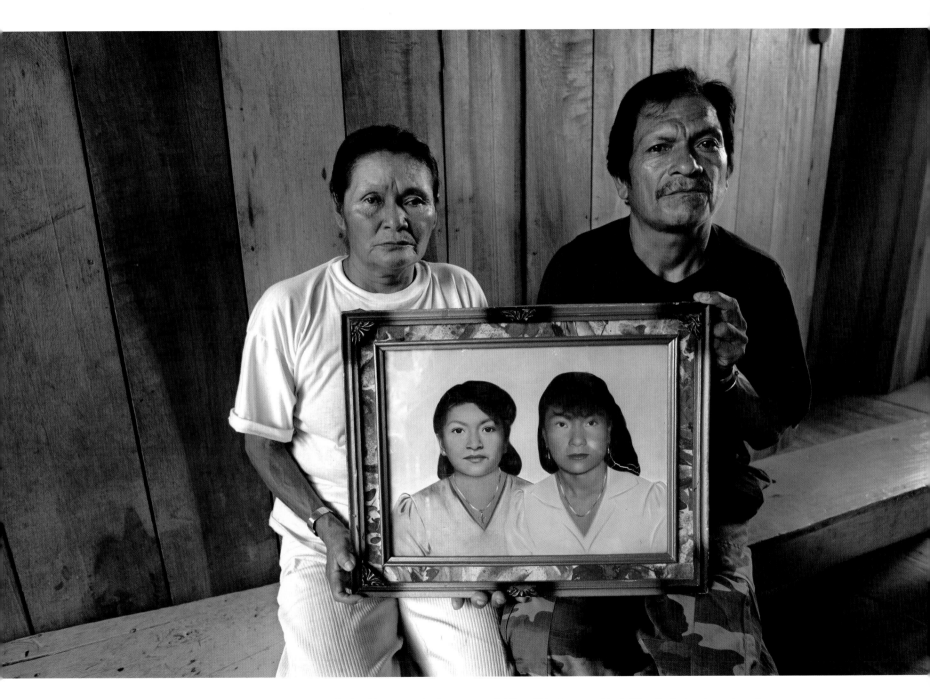

Miguel Mashumar and Maria Claudia Antuash sit with a portrait of their deceased daughters Rosa and Maria Graciela at their home on the Via Auca.

Miguel Mashumar y María Claudia Antuash contemplan un retrato de sus hijas fallecidas, Rosa y María Graciela, en su casa en la Vía Auca.

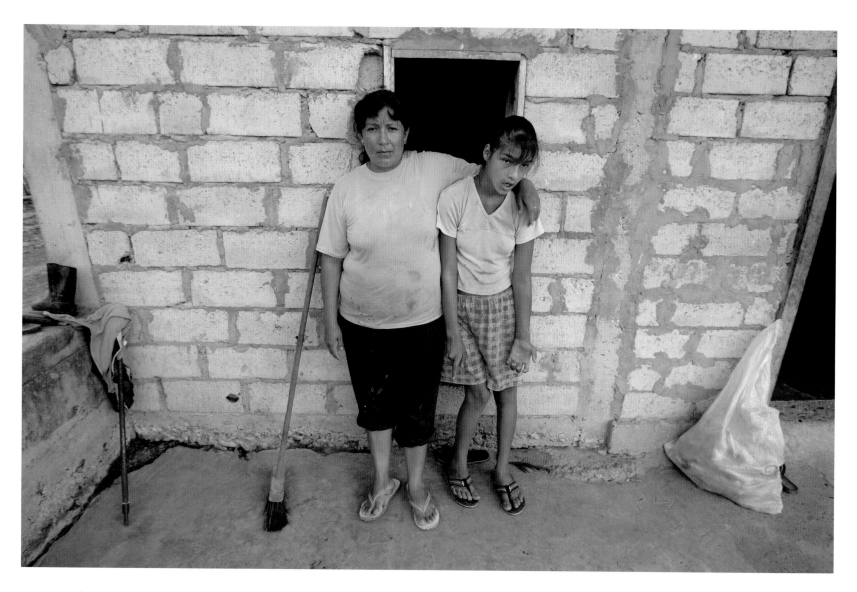

Carmen Guaman (L) with her 14-year-old daughter Veronica, who suffers from birth defects, at their home in La Primavera.

Carmen Guaman con su hija de 14 años Verónica, que sufre de defectos de nacimiento, en su casa en La Primavera.

Fifteen-year-old Myra Chicaiza sits with her mother Rosa Mercedes on the floor of their home in Dureno.

Myra Chicaiza, de 15 años, junto a su madre Rosa Mercedes sobre el suelo de su casa en Dureno.

Rosa Mercedes Chicaiza

Dureno

Her 15-year-old daughter Myra has birth defects

We've lived here in the Amazon for about 20 years. We're from the mountains of Santo Domingo. When we moved here, there were already [Texaco] oil wells, and [Texaco] open waste pits.

We dug two wells for water, but in both the water was mixed with oil. We washed clothes in the river but the water was full of oil. We also bathed in the river, which always makes you sick, gives you fevers, skin rashes, bumps. When I was pregnant, I bathed in the river. There was so much salt.

The girl is 15, and her name Is Myra Napo. She's very sick. She was born that way, not moving, with soft bones. The doctors were never able to tell me what was wrong with her.

Now she can sit up, crawl, pull herself along the floor, turn over. She says "mama," "papa" and cries when she's hungry or thirsty. She recognizes us and understands us. I have to feed her by hand.

As a mother, it is very difficult to take care of her. We all have to change her, clean her clothes. No one has ever helped us, except once the Catholic church gave us a wheelchair. Her siblings used to take her out, but now the wheelchair is too small for her. It would be nice if someone could donate a wheelchair so we could take her outside and she wouldn't be trapped in this room.

The neighbors and their children come here to stare at her. Sometimes I've heard it said that I shouldn't take care of her anymore; that it would be better not to give her anything to eat. But I say, how could I not feed my own child?

Who wouldn't love this poor little child? All of us, including her brothers and sisters, love her. And that's why we don't call her by her name, but instead call her "mama," because she is the mother of all of us.

I know she won't be with us on earth for long. She is very sick. This makes me sad for her, because we'll never find a way to make her well.

Rosa Mercedes Chicaiza

Dureno

Su hija Myra, 15 años, nació deformada

Acá en el oriente tenemos más de 20 años. Venimos de Santo Domingo. Ya había pozos de petróleo [de Texaco] y piscinas abiertas [de Texaco] cuando llegamos.

Aquí hicieron dos pozos de agua pero no sirvieron porque el agua salía grasosa. Lavábamos en el río, pero salía la grasa de petróleo. También nos bañamos en el río. El río siempre le da una fiebrita, le pica el cuerpo y le da también unos granitos. Cuando estuve embarazada, me bañaba en el río. Había mucha sal.

La niña tiene 15 años, se llama Myra Napo. La niña está enferma. Ella nació así, no tenía movimiento, sus huesitos eran suavecitos. Los doctores del hospital nunca me supieron decir qué enfermedad tenía.

Ahora ella se sienta, se arrastra, camina de nalguitas, se voltea. Dice "mamá," "papá." Cuando ella tiene hambre o sed llora. Ya nos reconoce.

Sí entiende porque ella escucha. Yo le doy de comer en la boquita.

Como madre, cuesta mucho cuidar de ella y de todo a la vez. Tenemos todos que cambiarle, lavar la ropa. Nunca nos han ayudado con la niña, sólo en la misión de la Iglesia Católica le donaron una silla. La sacaban los hermanitos, pero ya es muy pequeña la silla. Sí nos pudieran donar otra silla sería bueno para sacarla del encierro, de estar solamente en el cuarto.

Así, los vecinos por aquí y los niñitos vienen a mirar. A veces he oído que dicen que yo no la debería de cuidarla más. ¿Para qué cuida usted esa niña? Mejor no le dé de comer. Digo yo, ¿por qué no darle de comer a mi hija?

¿Quién no va a querer a la pobrecita? Aquí, los hermanitos, todos la quieren a ella. Por eso a ella no la llaman por su nombre, no, sólo le dicen "Mamá." Todos la quieren, ella es la mamá aquí de nosotros.

Ella no nos va a acompañar por largo tiempo. Ella está enfermita y esto me da tristeza. Yo me siento algo triste por ella porque no le encontramos una mejoría.

With her 8-year-old sister Alexandra Raquel at left, 15-year-old Myra Chicaiza sits on the floor of her home in Dureno.

Myra Chicaiza, de 15 años, sentada sobre el suelo de su casa en Dureno con su hermana de 8 años Alexandra Raquel (izquierda).

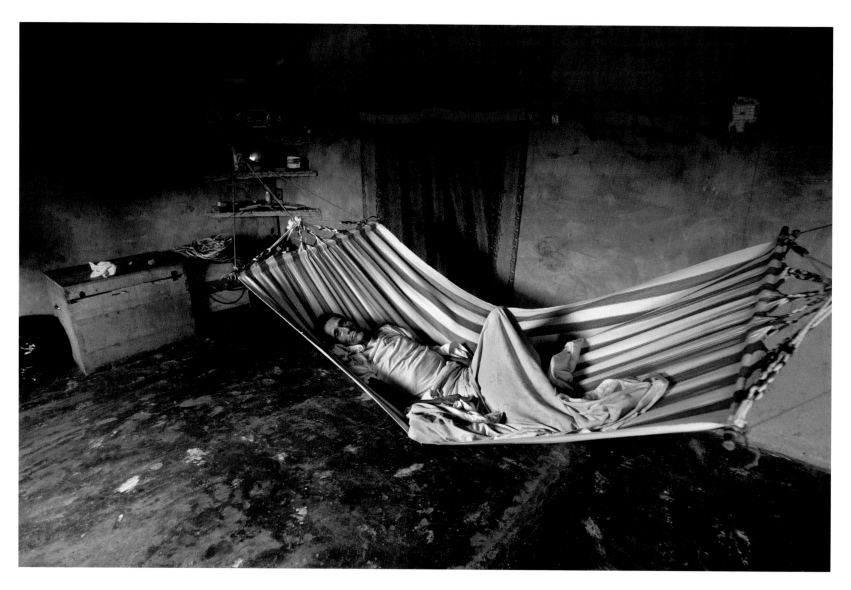

Angel Toala lies in his home in Shushufindi one day before he died of stomach cancer.

Ángel Toala yace agonizando en su casa en Shushufindi, un día antes de su muerte a causa de cáncer de estómago.

Fresh crude oil covers a road leading to the Cuyabeno Wildlife Preserve in 1993.

Camino que conduce hacia la reserva natural de Cuyabeno cubierto de petróleo crudo en 1993.

Luz Maria Marin, widow

Texaco Shushufindi Oil Field / Shushufindi
Husband Angel Toala died of stomach cancer

My husband, Angel Toala, and I came here to the Amazon 23 years ago from the mountains in Santo Domingo. We came because he was told you could earn good money with the [oil] companies here. We have six children.

Angel worked on the pipeline for Texaco for five years, and that is how we've been able to buy this farm. Mostly we grew coffee, plantains, yucca, some cacao.

There's a [Texaco] pumping station near our house and a [Texaco] oil well 200 yards from our house, and downstream is a lake where the crude oil they dumped gathers. We never let the animals drink this water. A lot of times we found dead fish in it. Our coffee plants there turned yellow and died.

We got our drinking water from the rain, and, when it didn't rain, from the stream. It had a funny taste and sometimes you could see oil floating on top. We bathed there and washed our clothes there. We knew the water was bad for our health, but what could we do? There wasn't water anywhere else.

I don't think the oil company worried if they contaminated the water. We farmers didn't realize the water was contaminated, and certainly it was not in the oil company's interest to tell us that.

About three years ago, my husband started having stomach pains, slight pains when he ate. He couldn't eat as much as he used to. (*Crying*) Certain foods made him feel bad, and he couldn't eat meat, or fish. About a year ago he started losing weight.

(*Crying*) Then his back began hurting, and his muscles. He felt tired. At the end, he couldn't take the sun. He was so tired; he didn't have any energy.

In Quito he was diagnosed with stomach cancer. We took him to the Eugenio Espejo Hospital but the doctors said that it was too late, nothing could be done.

(*Crying*) The last three months before he died, he couldn't do anything. He just lay in the hammock.

Luz María Marin, viuda

Texaco Campo Shushufindi / Shushufindi
Esposo Ángel Toala murió de cáncer de estómago

Mi esposo, Ángel Toala, y yo vinimos aquí hace 23 años de Santo Domingo. Vinimos por la situación económica y porque a él le dijeron que en las compañías [petroleras] se ganaba dinero. Tenemos seis hijos.

Él trabajó cinco años en tubería de Texaco y así conseguimos esta finquita y pudo comenzar a trabajar aquí. Primeramente sembraba café, plátano, yuca, un pequeño pedacito de cacao.

Cerca de la casa hay una estación [de Texaco] y a 200 metros de la casa está un pozo [de Texaco], incluso allá abajo hay una laguna donde se estancaba ese crudo que botaban. No dejábamos a los animales beber de esa agua. En muchas ocasiones hallamos pescados que se morían. El café aquí en la cafetera comenzó a amarillearse.

Recogíamos agua de la lluvia para tomar y en otras ocasiones íbamos al río cuando no llovía. A veces el agua tenía un sabor distinto, se sentía como aceitosa el agua por encima. Igual nos bañábamos y lavábamos en el rió.

Claro que sabíamos que el agua era mala para la salud, pero ¿qué podíamos hacer?, no había más.

La compañía petrolera, creo que no se preocupó de que eso estaba contaminado. Aquí los habitantes no nos dábamos cuenta si el agua estaba contaminada y a ellos no les conviene decir que el agua está contaminada. La enfermedad de mi marido comenzó con problemas de estómago, hace como más o menos tres años. Sentía un poquito de dolor y ya no podía comer en la cantidad que comía antes. (*Llorando*) Cierta comida ya le hacía daño, ya no podía comer la carne, el pescado. Comenzó a adelgazarse hace casi un año.

(*Llorando*) Le dolía la espalda, muchas veces los músculos, sentía cansancio y al final, ya no podía recibir el sol, ya se cansaba, ya no podía hacer esfuerzos.

En Quito le diagnosticaron cáncer. Lo llevamos a Eugenio Espejo pero los médicos dijeron que ya no se puede hacer nada.

(*Llorando*) Tres meses antes del fallecimiento de él, ya no pudo hacer nada. Se quedó en las hamacas.

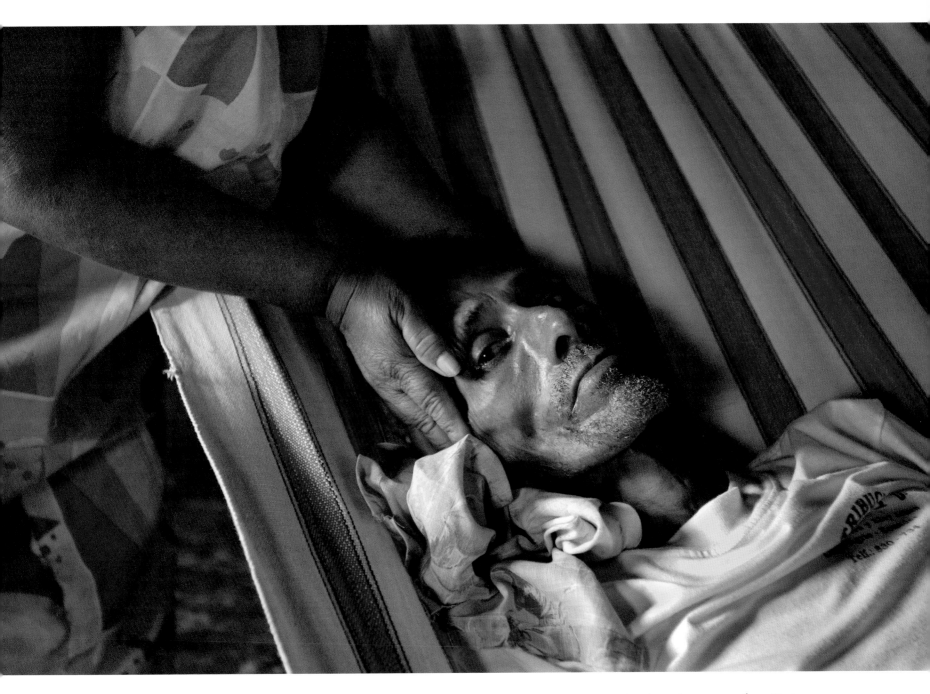

Luz Maria Marin holds the head of her husband Angel Toala one day before he died of stomach cancer in his home in Shushufindi.

Luz María Marin sostiene la cabeza de su esposo Ángel Toala un día antes de su muerte a causa de cáncer de estómago en su casa en Shushufindi.

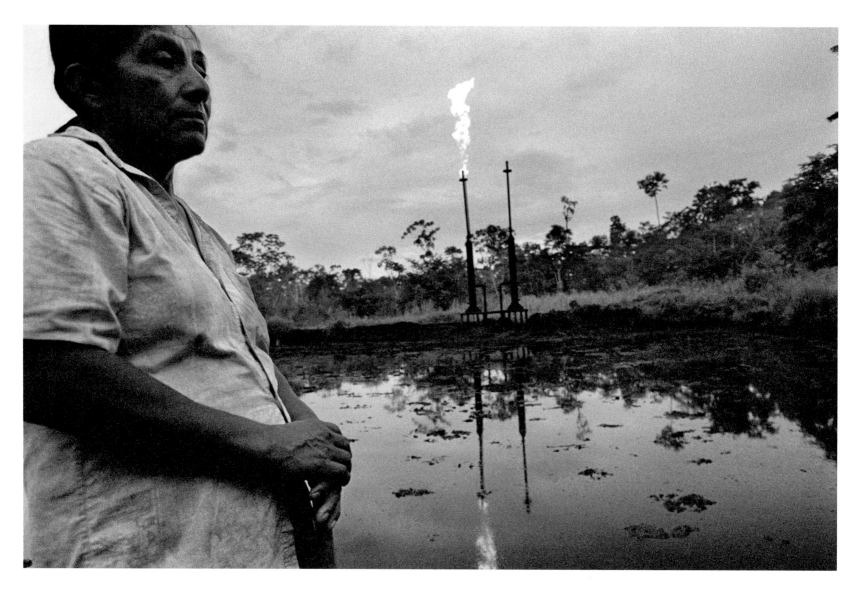

Maria Bravo stands by an open waste pit near her home in the Guanta oil field.

María Bravo junto a una piscina de desechos tóxicos, ubicada cerca de su casa en el campo petrolero de Guanta.

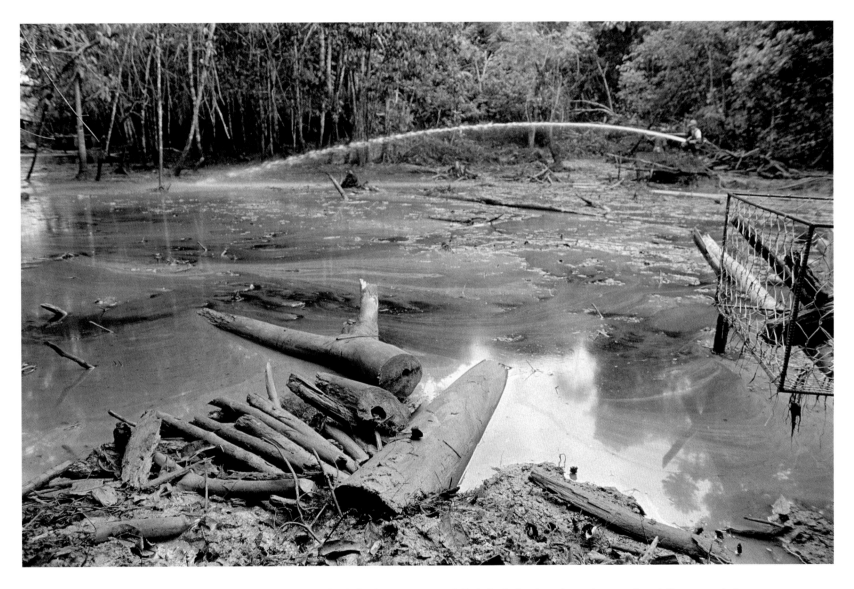

Oil spill cleanup effort next to the PetroEcuador North Sacha Station.

Trabajo de limpieza de un derrame de petróleo cerca de la Estación Sacha Norte de PetroEcuador.

Blanca Mendez

San Carlos
Son Jose born with birth defects

We've lived here in San Carlos for 15 years. My family drinks water from the river nearby and we wash clothes there. The river has petroleum in it that came from Texaco. The contamination is still there today.

I have 6 children. Jose is the last one. His birth was normal, but when he was one, he still wasn't walking. He's 6 and he doesn't talk, nor feed himself. He can't walk by himself either. He tries to, but half of his body doesn't work. He understands some things but he doesn't go to school.

I think he is this way because of the contamination here.

I feel bad. I really can't see a future for my son.

Hijo José nació con defectos de nacimiento

Son 15 años que vivimos aquí en San Carlos. Tomamos agua del río y lavamos la ropa allí. Está bien contaminado. Hay puro petróleo en el agua. Era de la Texaco. Sigue, todavía estando contaminado.

Son seis hijos que tengo. José es el último. Fue un parto normal, pero al año… ya no caminó. Tiene 6 años y no habla, ni come, ni puede caminar por sí mismo. Sí intenta caminar, pero la mitad del cuerpo no le funciona. Algo sí entiende, pero no va a la escuela.

Pienso que la contaminación aquí es culpable de esto.

Yo me siento mal. En realidad es difícil ver un futuro para mi hijo.

Jose Mendez sitting outside of his home in San Carlos.

José Mendez sentado fuera de su casa, en San Carlos.

Jose Mendez with his mother Blanca Mendez and grandmother at their home in San Carlos.

José Mendez junto a su madre Blanca Mendez y su abuela en su casa en San Carlos.

Toribio Aguinda

Former President of the Cofan Federation
Dureno

The government took away our territory and gave our lands to the settlers. We Cofanes were very innocent in those times and we didn't know how to demarcate our lands. This was due to our ignorance, but now we indigenous people know how to mark our territory.

Before, most of the Amazon was considered "empty." The government promoted settlement of these lands, and gave settlers incentives to come here to farm. Along with Texaco came settlers and missionaries.

The government never respected our indigenous culture. When the government finds an endangered animal, like a frog, they create a biological preserve to protect it, but they won't do that for indigenous communities.

Our lands are surrounded by settlers now. The Cofanes are not able to cross the river because it's not our land anymore. If we crossed the river, it would be considered trespassing into the settlers' territory.

Although we consider those lands our ancestral territory, we can't get it back. When the oil company built the highway, some indigenous people left their territory because they didn't want to live next to a highway, and that was how they lost their lands.

The contamination is in the water. People in this community don't drink water from the Aguarico River because it contains oil; we drink water from a spring. We still bathe in the river, but we get sick a lot; we get a lot of skin rashes.

There's only one oil well in Cofan territory, but most of the pollution comes from the Aguarico River and the Pisorie River that has oil wells near its headwaters, and those rivers are permanently contaminated with oil spills. On the shorelines, a black line of crude marks the rocks.

Five years ago, two people died from the effects of pollution. Many people also have skin rashes, stomachaches, diarrhea, dizziness; some have died because of cancer. Some women have had miscarriages.

Toribio Aguinda

Ex-presidente de la federación Cofán
Dureno

El gobierno le dió nuestras tierras a los colonos que inmigraron y nos quitaron nuestro territorio. Inocentemente los Cofán nos quedamos sin tierra, no sabíamos como delimitar nuestro territorio. Este problema fue por nuestro desconocimiento, pero ahora los indígenas sabemos como delimitar nuestro territorio.

Antes, la mayor parte de la región amazónica era considerada baldía. Luego hubo una campaña del gobierno, para apoyar la producción agrícola, en la que incentivaron a los colonos a venir. Con la llegada de Texaco vinieron los colonos y algunos misioneros.

El gobierno nunca apreció la cultura indígena. Por ejemplo, cuando encuentran un animal en peligro de extinción, como una rana, declaran reservas biológicas para protegerla, pero no reservas culturales para proteger las comunidades indígenas.

Nuestras tierras están rodeadas de colonos actualmente. Los Cofán no podemos cruzar el rió porque ese terreno ya no es más parte de nuestro territorio. Si cruzamos el rió, estaríamos invadiendo territorio de los colonos.

Aunque consideramos ese nuestro territorio ancestral, ya no lo podemos recuperar. Incluso algunas personas, cuando la compañía abrió la carretera, abandonaron sus territorios porque no querían vivir al lado de la carretera, y fue así que perdieron sus terrenos.

La contaminación está en el agua. Las personas de esta comunidad ya casi no toman agua del río Aguarico porque está contaminada con crudo, tomamos agua de una vertiente natural. Sin embargo, todavía nos bañamos en el río porque no hay en donde más, aunque a veces nos enfermamos, algunos tienen granos en el cuerpo.

En territorio Cofán hay sólo un pozo, pero la mayoría de la contaminación viene por el río Aguarico y el río Pisorie que tiene pozos cerca de su cabecera que lo contaminan permanentemente con derrames de crudo. Este río se puede ver un poco aceitoso y en sus orillas las piedras tienen líneas negras del crudo.

Murieron dos personas hace cinco años por la contaminación. También, en la comunidad muchas personas tienen problemas en la piel como granos en el cuerpo además de dolor de estomago, diarrea, mareos, cáncer y aborto.

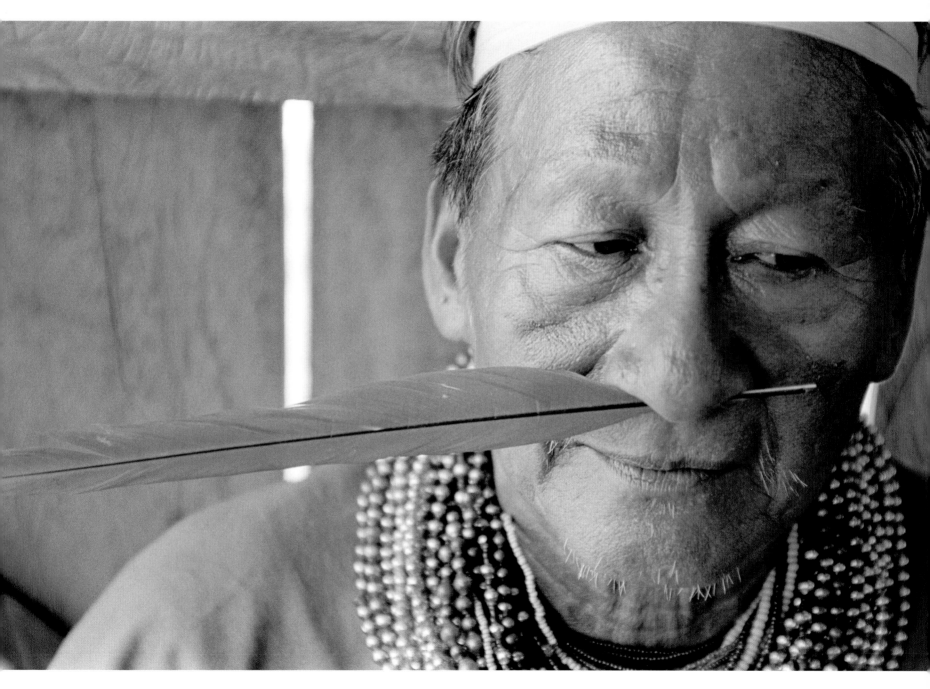

Cofan elder Aurelio with traditional makeup and feather adorn-
ment in Pisorie.

Aurelio, anciano Cofán, con su maquillaje tradicional y adornos
de plumas en Pisorie.

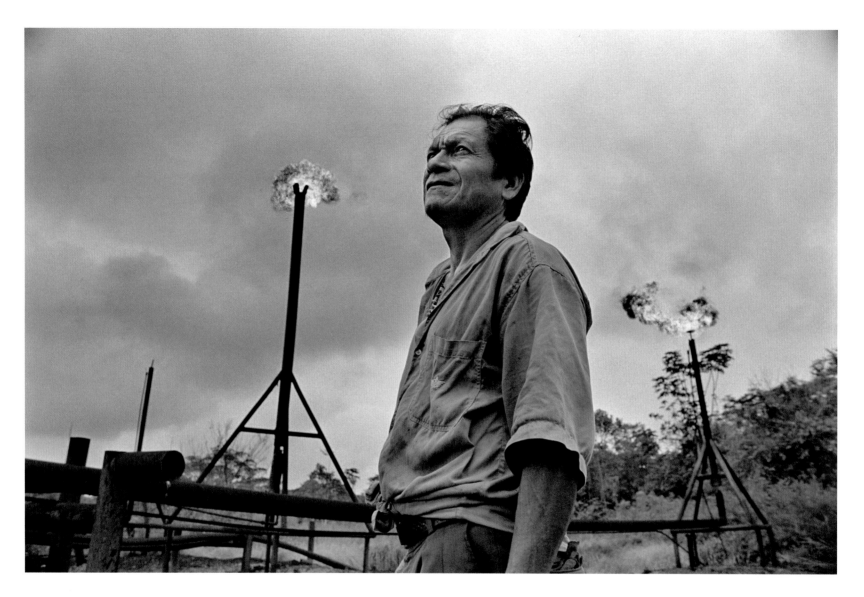

Miguel Mashumar stands by flares from the oil facility on his property on the Via Auca mile 28.

Miguel Mashumar junto a las instalaciones petroleras localizadas en su propiedad en Vía Auca km 42.

| Cofan children playing on old oil barrels in Dureno. | Niños Cofanes jugando sobre los barriles de petróleo en Dureno.

Secoya man playing a traditional flute in San Pablo. Hombre Secoya tocando una flauta tradicional en San Pablo.

Ricardo Piaguaje

President of the Secoya Federation
San Pablo

The Secoya people have always lived in a healthy envrionment. When Texaco came to the Amazon, they brought many machines, things we had never seen before. They used dynamite and drilling machines on our lands.

They drilled wells and set off dynamite next to our people's houses; it was a totally different world for us. We began to live in a world very different from before, with noise, big machines and oil spills and petroleum waste products. The oil companies penetrated areas of the Amazon where even the Secoya people had not been before.

When Texaco penetrated our territory, settlers followed. They invaded our ancestral lands; now we're like a small island surrounded by settlers. Texaco built roads to the oil wells, and this opened the floodgates to ambitious settlers who are hungry for land. The government gave land titles to the settlers; we've lost a lot of our territory. Now, our indigenous land is in a national reserve, so we can protect the environment.

One of the biggest cultural impacts of the oil development was the contamination of the rivers and the fish. Many people suffer from skin rashes and inflamed glands, and some, like my grandfather, have cancer.

I hope that the Secoya people will flourish; that we can live in a healthy, uncontaminated environment. Also, to maintain our culture, we need to teach our children Secoya traditions.

If I could say something to Texaco, I'd tell them that they've destroyed our culture and our environment here in the Amazon and they should admit this. We're a minority group and they should help us. They have damaged our lands and rivers, they've contaminated the air, and they should clean it up.

Texaco should think of the Secoyas as people, that we're human beings, not animals. They should stop denying everything, and they ought to compensate us for the damage they've done to our lands, because we've lived in the Amazon for thousands of years.

Ricardo Piaguaje

Presidente de la federación Secoya
San Pablo

Los Secoyas siempre hemos vivido en un ambiente sano. Cuando Texaco vino a la Amazonía trajeron muchas máquinas y cosas que nunca antes habíamos visto. Usaron dinamita y taladros para internarse en la región Amazónica.

Perforaron pozos y explotaron dinamita cerca de nuestras casas. Empezamos a vivir en un mundo muy diferente al de antes, con ruido, máquinas grandes, con derrames y desperdicios de petróleo. La compañía se fue internando en partes de la selva donde ni siquiera nosotros habíamos estado.

Luego de que la compañía Texaco entró a nuestro territorio, siguieron los colonos que invadieron nuestras tierras ancestrales. Ahora estamos como en una isla, tenemos un pequeño territorio rodeado de colonos. Texaco construyó carreteras para llegar a los pozos y llegaron los colonos que estaban ambiciosos buscando territorios para colonizar. El gobierno también dio títulos a los colonos y así hemos perdido mucho de nuestro territorio ancestral. Hoy nuestro territorio es una reserva nacional y esto nos permitirá proteger el medio ambiente.

Uno de los mayores impactos del desarrollo petrolero fue la contaminación de los ríos. La contaminación afecta nuestra salud, por el agua contaminada muchas personas tienen granos en la piel, glándulas inflamadas y algunos como mi abuelito sufren de cáncer.

Espero que los Secoya podamos vivir en un ambiente sano y sin contaminación. También, necesitamos enseñarle a nuestros hijos las tradiciones Secoya, para mantener nuestra cultura.

Si le pudiera decir algo a Texaco, le diría que han destruido nuestra cultura y nuestro medio ambiente aquí en la Amazonía y deben reconocer los daños que han hecho. Nosotros somos un grupo minoritario y deberían ayudarnos. Han dañado nuestras tierras y nuestros ríos, han contaminado el aire y deben limpiarlo.

Texaco debe considerar a los Secoya como personas, somos seres humanos y no animales. La compañía debe preocuparse y reconocer el daño que nos hicieron, también debe dar una compensación, porque somos habitantes milenarios de la región Amazónica.

Venancio Criollo

President of the Siona Federation

When the oil companies arrived, many problems arose that we had never seen before. In the beginning we thought the companies would help us, but now we see that reality is different. The oil companies have hurt the communities. They have contaminated the birds and the fish that we eat. They have contaminated our water with oil spills. We have been affected by disease and illness, especially the children. Also, we've lost much of our culture. Our language and our customs have been lost. Chevron's contamination remains in our land, and it continues to affect us as well as other friends, like the Secoya. And it is because of this that we continue the lawsuit in search of a solution to the damage that the oil companies have done to our communities, to our water and to the environment.

Presidente de la federación Siona

Desde que llegaron las petroleras hemos tenido problemas que nunca antes habíamos visto. Pensamos en un principio que nos iban a apoyar, pero vimos que la realidad fue otra. Las petroleras han venido para afectar a las comunidades con la contaminación de las aves y el pescado que comíamos y han contaminado el agua que bebíamos con los derrames de crudo; no tenemos ya de donde tomar agua. Hemos tenido muchas enfermedades, sobre todo problemas con los niños. También, hemos perdido bastante la cultura, se ha perdido el idioma y las costumbres. La contaminación de la compañía Chevron permanece hasta ahora y nos afecta a nosotros y a otros compañeros como los Secoya, y por eso seguimos con este juicio, para que avance y puedan solucionar el daño que han hecho a las comunidades, el agua y el medio ambiente.

Siona shaman in Puerto Bolivar.

Shamán Siona en Puerto Bolívar.

Pamela Ramirez, born with a birth defect, at her home in San Carlos.

Pamela Ramírez, quien nació con una deformación, en su casa en San Carlos.

History of The Trial

In 1993, a class-action lawsuit against Texaco was filed in New York Federal Court on behalf of 30,000 Ecuadorans, including five indigenous groups and 80 rainforest communities. Called *Aguinda v. Texaco*, the lawsuit claimed that Texaco caused severe environmental and health damage in areas where it drilled oil wells, and sought clean up and personal damages for the impact of the oil company's dumping of toxic waste into the Amazon rainforest. After years of legal skirmishing over jurisdictional issues, the federal court issued a groundbreaking ruling in 2002 that forced Chevron (formerly Texaco) to accept jurisdiction in Ecuador or face trial in the United States.

The case was then re-filed in May 2003 in Ecuador. The trial began in October of that year in in Lago Agrio, a small town in Ecuador's Amazon region. Civil trials in Ecuador allow three phases: a 6-day proof period, where the parties present and cross-examine witnesses and submit documentary evidence (October 2003); judicial inspections, where the judge visits sites in the field and appoints experts to submit reports on technical matters, such as levels of contamination (August 2004 to 2006); and finally, an expert assessment from the parties, where technicians analyze issues and submit reports to the court (expected to be completed in 2008). A decision will come after the end of phase three. The losing party will have the right to appeal to Ecuador's Supreme Court, a process that could take another two to three years.

Uterine cancer victim Rosana Sisalima at her home in San Carlos a year before she died in May 2006.

Rosana Sisalima, en su casa en San Carlos, un año antes de morir en Mayo del 2006, víctima de cáncer de útero.

Historia del Juicio

En 1993, una demanda colectiva en contra de Texaco fue interpuesta ante la Corte Federal de Nueva York en representación de 30,000 ecuatorianos que incluyen cinco grupos indígenas y 80 comunidades de la selva. Bajo el nombre de *Aguinda vs. Texaco*, esta demanda alega que Texaco causó daños ambientales severos y a la salud de los habitantes en áreas en las que perforó pozos y busca que la compañía se haga responsable por la limpieza y daños personales causados por el vertimiento de desechos tóxicos en la Amazonía. Después de años de enfrentamientos legales sobre asuntos de jurisdicción, en el 2002 la Corte Federal emitió un fallo histórico y obligó a Chevron (antes Texaco) a aceptar jurisdicción en Ecuador o someterse a juicio en los Estados Unidos.

El mismo caso fue presentado en Mayo del 2003 en Ecuador. El juicio comenzó en octubre de ese año en Lago Agrio en la Amazonía ecuatoriana. Los juicios civiles en Ecuador constan de tres partes: un período de pruebas de seis días en el cual las partes presentan e interrogan testigos y presentan evidencia documentada (octubre del 2003); desarrollo de las inspecciones judiciales, donde el juez visita los lugares afectados y elige expertos para que presenten reportes en materias técnicas como los niveles de contaminación (agosto del 2004 al 2006); y finalmente, una evaluación de las partes, donde expertos técnicos analizan los temas y entregan reportes a la corte (se espera finalice en el 2008). La decisión se da al final de la tercera fase. La parte perdedora tendría derecho a apelar ante la Corte Suprema de Ecuador, lo que podría tomar otros dos o tres años.

Ermel Chavez, President of the Amazon Defense Front, faces the flares of the old Texaco oil facility in Sacha during a court-ordered inspection.

Ermel Chávez, Presidente del Frente de Defensa de la Amazonía, observa los mecheros de las antiguas instalaciones petroleras de Texaco en Sacha, durante una inspección ordenada por la Corte.

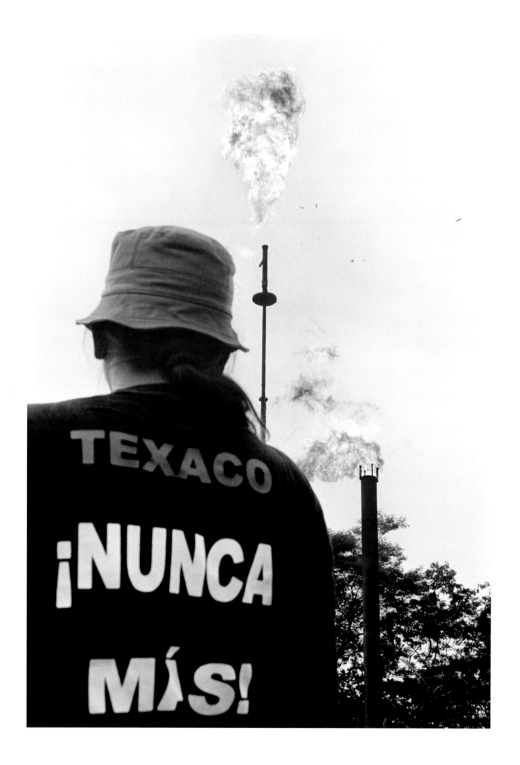

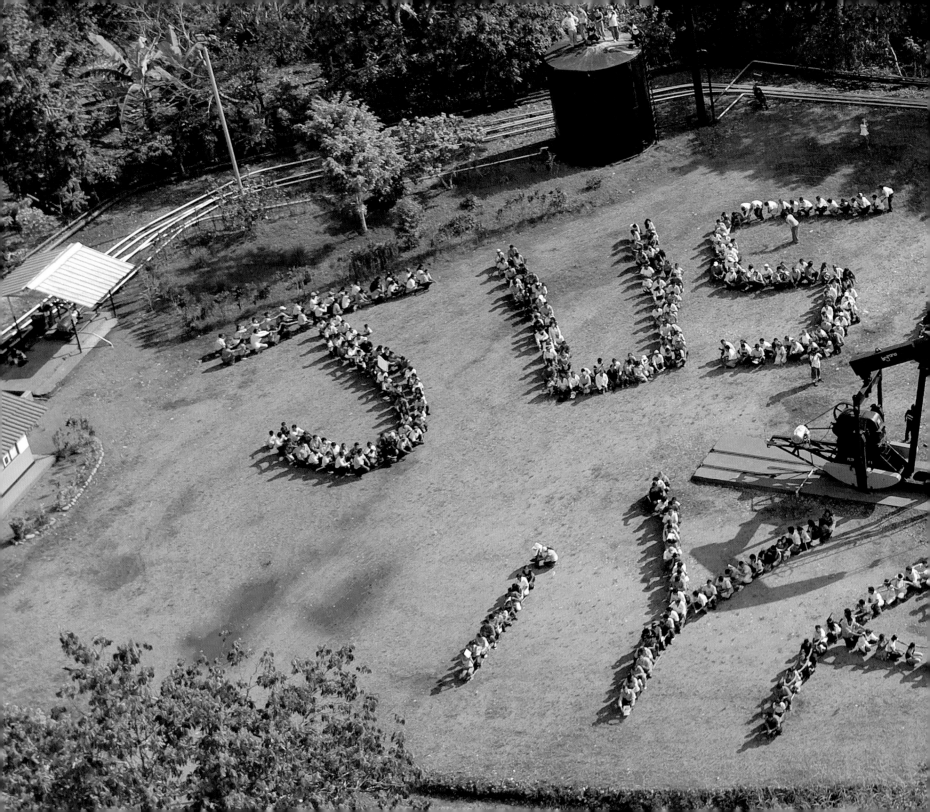

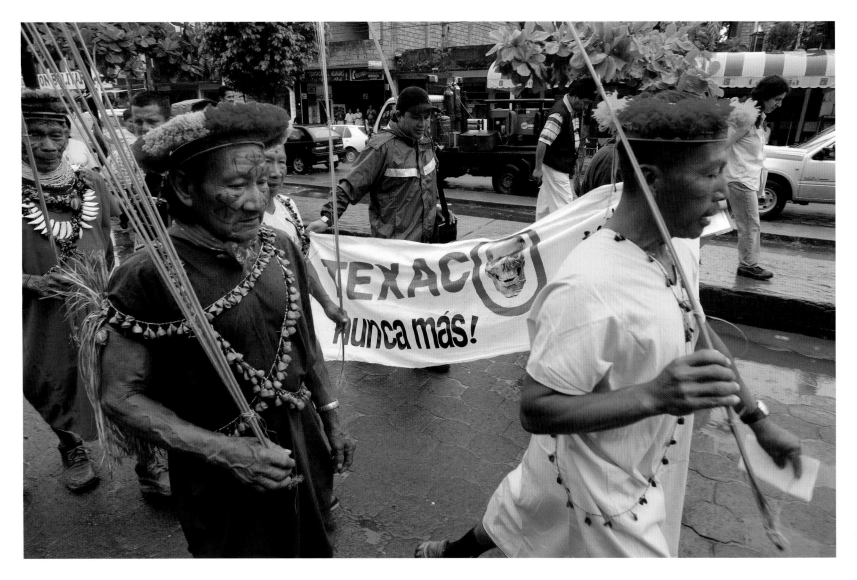

Secoya and Cofan leaders march to the Superior Court of Justice in Lago Agrio at the start of the trial against Chevron (formerly Texaco) on October 21, 2003.

Líderes de los grupos indígenas Secoya y Cofán marchando hacia la Corte Superior de Justicia, en Lago Agrio al inicio del juicio contra Chevron (antes Texaco), el 21 de octubre del 2003.

pgs. 74-75 | *Plaintiffs in the lawsuit against Chevron (formerly Texaco) gather at the site of the oil giant's first well in the Amazon rainforest outside the town of Lago Agrio to demand "Justice Now!"*

Superior Court Judge Alberto Guerra speaks to a packed courtroom on the first day of the trial against Chevron (formerly Texaco) in Lago Agrio.

El Juez de la Corte Superior de Justicia, Alberto Guerra, se dirige a una sala llena de gente, en el primer día del juicio contra Chevron (antes Texaco), en Lago Agrio.

págs. 74-75 | *Demandantes en el caso en contra de Chevron (antes Texaco) se juntan cerca al primer pozo de la compañía, en la selva Amazónica en las afueras de Lago Agrio para pedir "Justicia Ya!"*

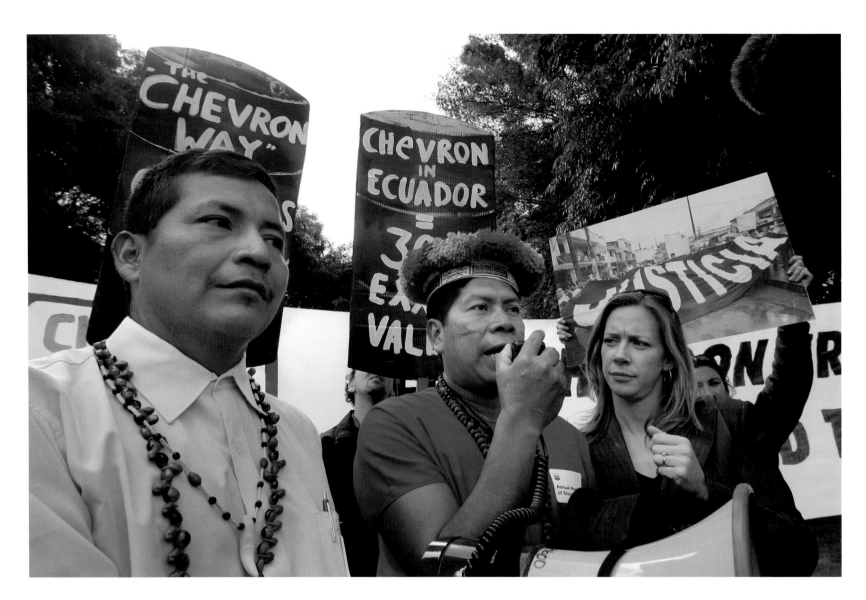

Secoya indigenous leader Humberto Piaguaje (C) is joined by Kichwa leader Guillermo Grefa (L) as he speaks to the press and supporters after emerging from Chevron's (formerly Texaco) annual shareholders meeting in San Ramon, California in 2007.

Líder indígena Secoya, Humberto Piaguaje, junto al líder Kichwa Guillermo Grefa a la izquierda, habla con la prensa y simpatizantes luego de salir de la asamblea anual de Chevron (antes Texaco) en San Ramon, California en 2007.

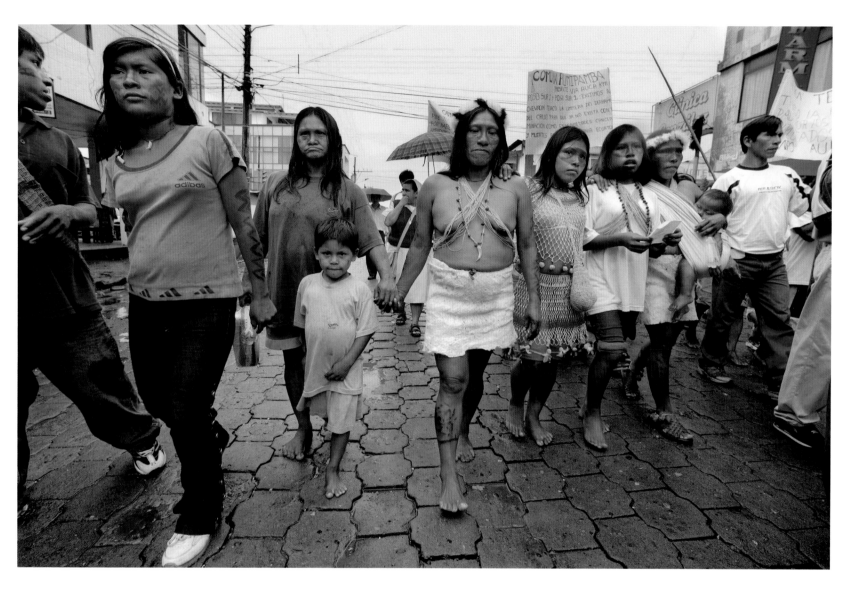

Huaorani women march to the Superior Court of Justice in Lago Agrio at the start of the trial against Chevron (formerly Texaco) in October 2003.

Mujeres indígenas de la nacionalidad Huaorani en la marcha realizada hacia la Corte Superior en Lago Agrio al inicio del juicio contra la compañía Chevron (antes Texaco), en octubre 2003.

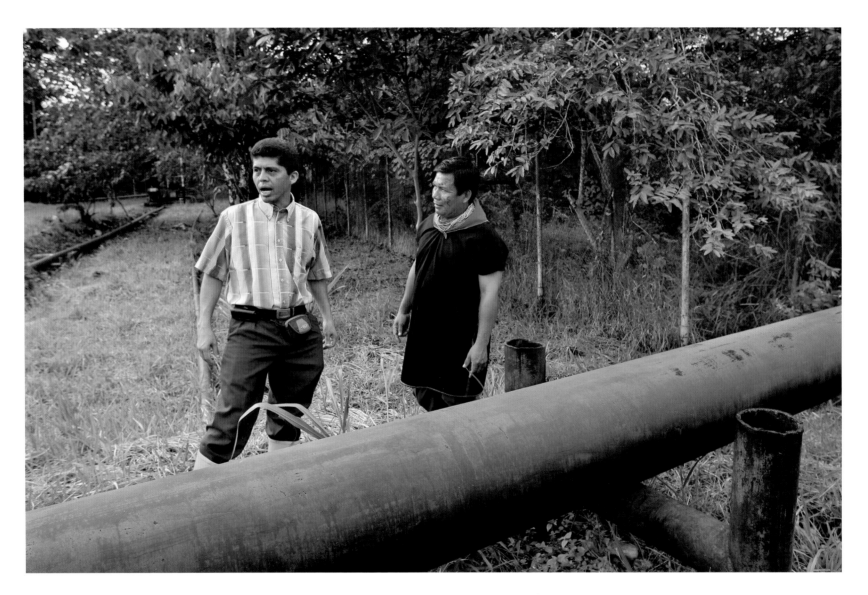

Pablo Fajardo (L), lead Ecuadoran attorney on the Chevron case, speaks with Cofan indigenous leader Emergildo Criollo at an oil facility in the Guanta oil fields. The plant was built by Texaco (now Chevron) on Cofan ancestral territory.

Pablo Fajardo, a la izquierda, abogado ecuatoriano del caso en contra de Chevron, habla con el líder indígena Cofán Emergildo Criollo en una instalación petrolera en el campo de Guanta. La planta fue construida por Texaco (actualmente Chevron) en territorio ancestral Cofán.

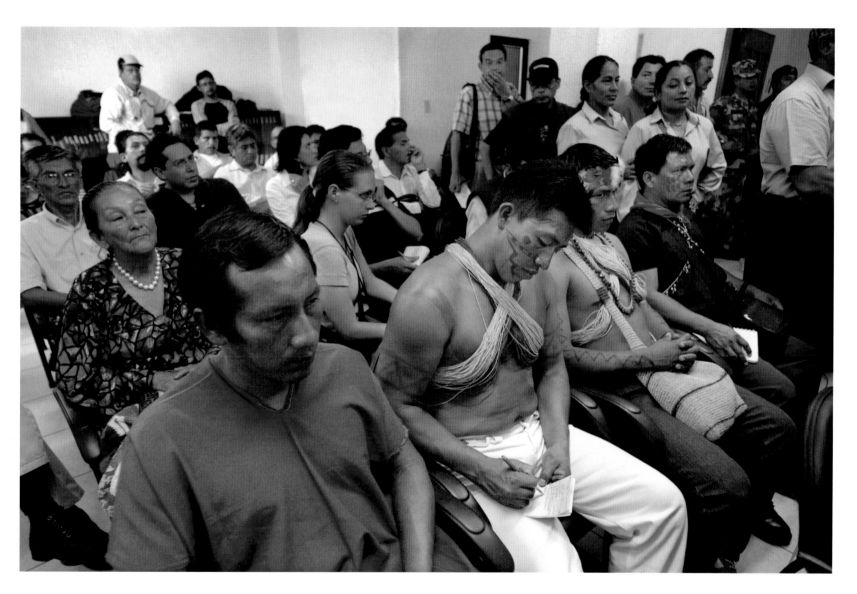

Indigenous leaders are joined by settlers, journalists and other interested parties on the first day of the trial against Chevron (formerly Texaco) in Lago Agrio on October 21, 2003.

Líderes indígenas junto a colonos, periodistas y demás miembros de grupos afectados, el primer día del juicio contra Chevron (antes Texaco) en Lago Agrio el 21 de octubre del 2003.

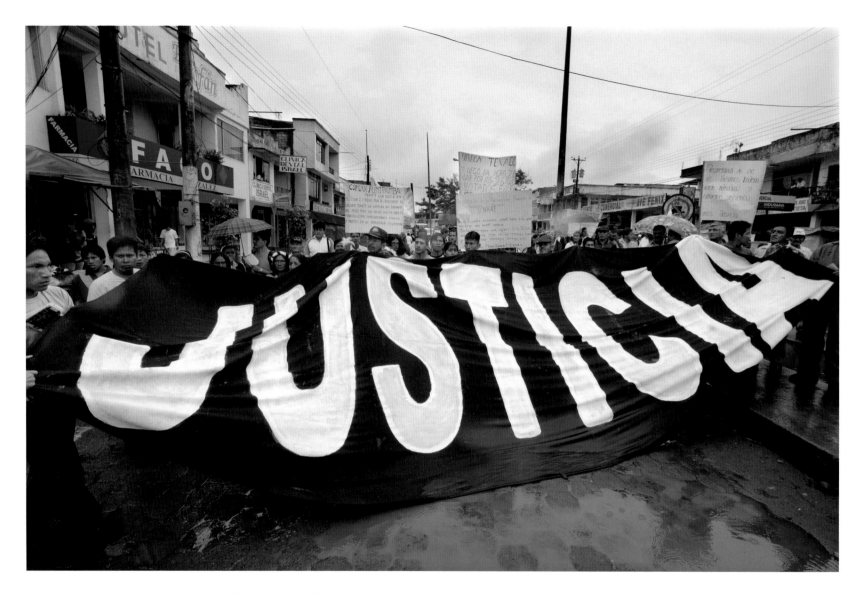

Demonstrators march to the Superior Court of Justice in Lago Agrio at the start of the trial against Chevron (formerly Texaco) on October 21, 2003.

Manifestantes marchan hacia la Corte Superior de Justicia, en Lago Agrio, al inicio del juicio en contra de Chevron (antes Texaco), el 21 de octubre del 2003.

Chevron vice president Ricardo Reis Veiga talks to the press in the Superior Court of Justice in Lago Agrio on the first day of the trial against Chevron (formerly Texaco).

Ricardo Reis Veiga, vicepresidente de Chevron habla con la prensa, en la sala de la Corte Superior de Justicia en Lago Agrio después del inicio del juicio en contra de Chevron (antes Texaco).

As Chevron technical expert John Connors (C) looks on, technicians in hazmat suits check a soil sample for evidence of crude oil during judicial inspections at an old Texaco well site near the town of Sacha.

Mientras el experto técnico de Chevron, John Connors (centro) vigila, técnicos usando ropa protectora para el manejo de sustancias peligrosas revisan una muestra de suelo para detectar evidencia de crudo durante una inspección judicial a un pozo viejo de Texaco cerca de Sacha.

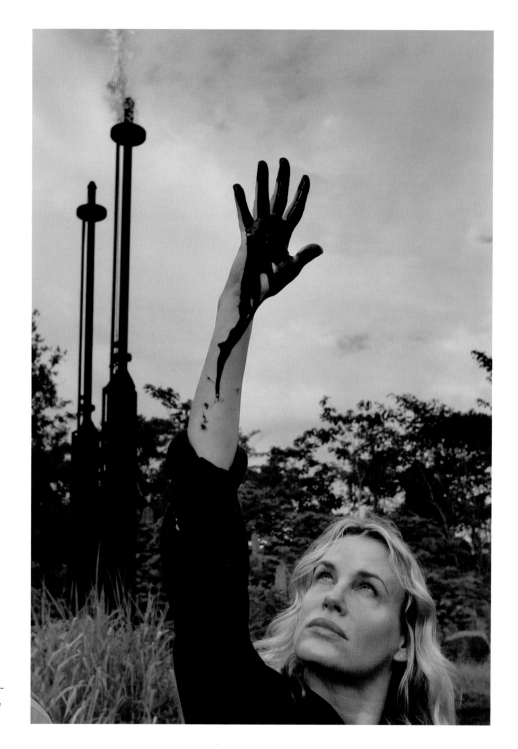

With an oil flare burning in the background, actress and environmental activist Daryl Hannah looks at her hand dripping with crude oil from a waste pit left by Texaco in the Guanta oil fields.

Con una llama de gas ardiendo en el horizonte, la actriz y ambientalista Daryl Hannah mira su mano cubierta de crudo, proveniente de una piscina dejada por Texaco en el campo petrolero de Guanta.

Steven Donziger, attorney for the affected communities, speaks to a group of Huaorani women at the start of the trial against Chevron (formerly Texaco) in Lago Agrio.

Steven Donziger, abogado de las comunidades afectadas, habla frente a un grupo de mujeres Huaorani al inicio del juicio en contra de Chevron (antes Texaco) en Lago Agrio.

pgs. 88-89 | *Demonstrators demand "Justice Now!" in the Chevron (formerly Texaco) trial as they march to the Superior Court in Lago Agrio.*
págs. 88-89 | *Manifestantes demandando "Justicia Ya!" en el juicio contra Chevron (antes Texaco), mientras marchan hacia la Corte Superior en Lago Agrio.*

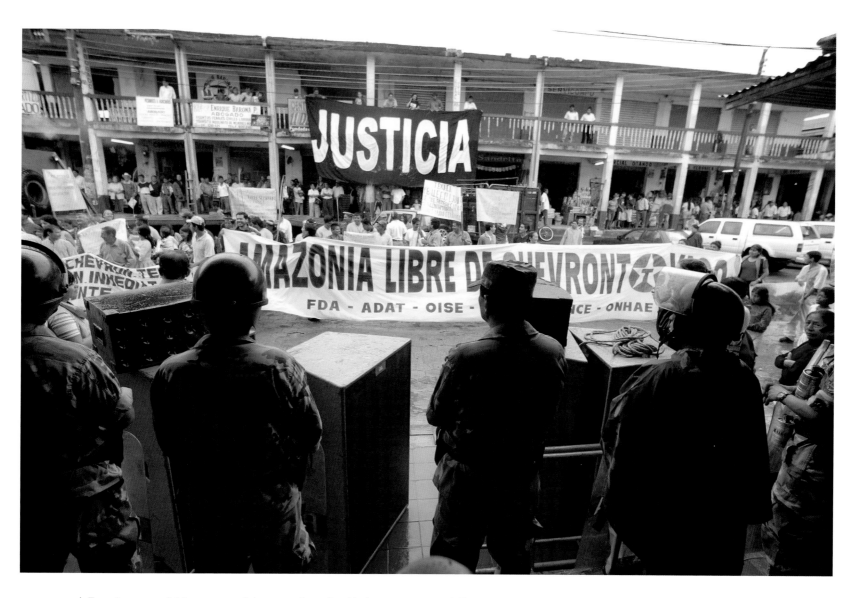

Ecuadoran special forces wear riot gear as they stand between demonstrators and the entrance to the courthouse in Lago Agrio at the start of the trial against Chevron (formerly Texaco).

Fuerzas especiales ecuatorianas usando equipo antimotín, parados entre los protestantes y la entrada de la Corte en Lago Agrio al inicio del juicio en contra de Chevron (antes Texaco).

pgs./págs.
88-89

Left to right/De izquierda a derecha: Guillermo Grefa (Kichwa); Luis Yanza (Amazon Defense Front/Frente de Defensa de la Amazonía); Humberto Piaguaje (Secoya); Emergildo Criollo (Cofán); Robinson Yumbo (Cofán).

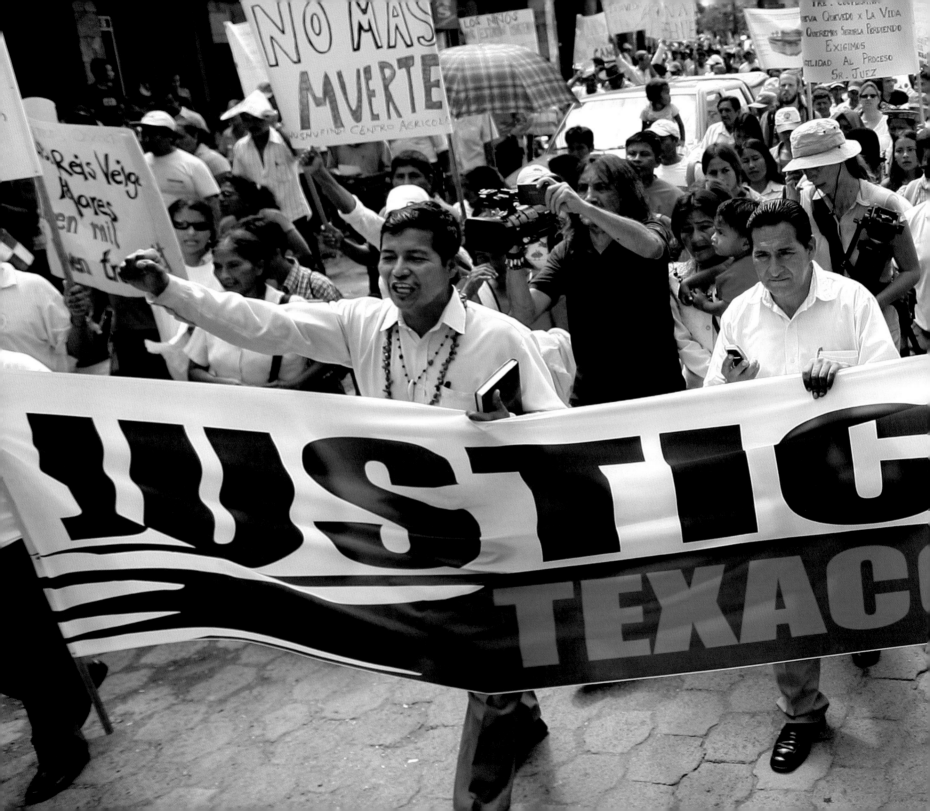

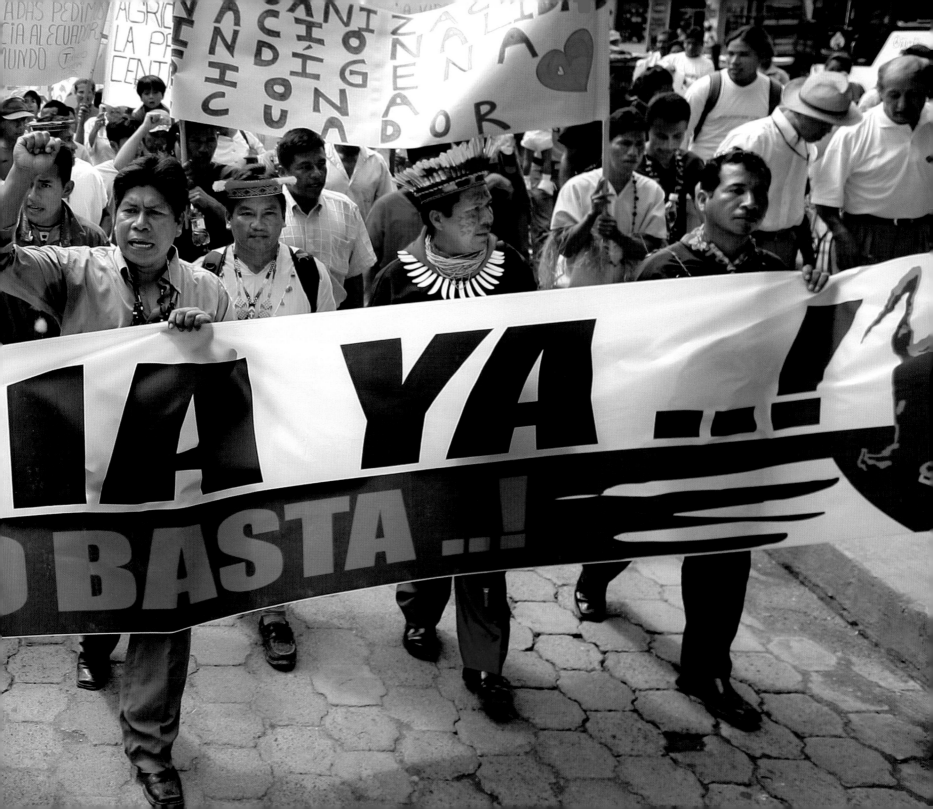

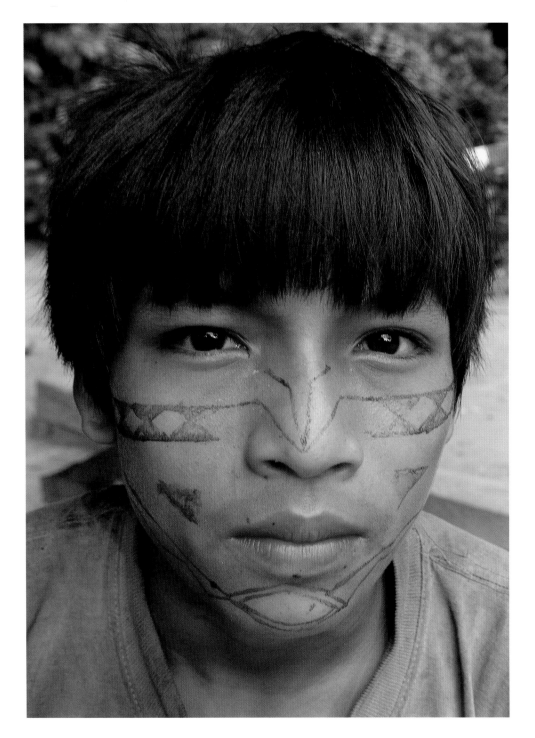

The Yasuni

In Ecuador's eastern Amazon region lies one of the most biologically diverse forests on the planet, the Yasuni. In just 2.5 acres of rainforest, there are nearly as many tree species as in the U.S. and Canada combined. Yasuni National Park is home to the Huaorani and some of the last indigenous peoples still living in voluntary isolation in the Amazon, the Tagaeri-Taromenani, whose ancestral lands sit atop Ecuador's largest undeveloped oil reserves, the Ishpingo-Tambococha-Tiputini (ITT) oil fields. The ITT holds nearly one billion barrels of oil, roughly 20 percent of the country's total reserves.

In 2007, Ecuadoran president Rafael Correa offered an unprecedented and historic proposal: Ecuador would not allow extraction of the ITT oil fields in the Yasuni if the international community would financially match half of the country's forgone oil revenues. If successful, the initiative will leave the crude permanently in the ground and help fund Ecuador's sustainable development into the future.

This visionary proposal would help prevent tropical de-forestation, which contributes between 20 to 25 percent of global greenhouse gas emissions, and would result in tangible and quantifiable reductions in carbon emissions from not burning fossil fuels.

pgs. 90-91 | *Indigenous peoples and supporters including Ecuadoran vice president Lenin Moreno spell out "Live Yasuni" in the Yasuni National Park as they launch the campaign to save the park from oil development.*

Kichwa youth Braulio Ikiami, 14, with his face painted to resemble a boa constrictor, outside his home in Sarayaku.

Braulio Ikiami, joven Kichwa de 14 años con su rostro pintado como boa, en su casa en Sarayaku.

El Yasuní

En la región este de la Amazonía ecuatoriana, se encuentra uno de los bosques tropicales más biodiversos del planeta. En tan sólo una hectárea de esta selva tropical, existen casi tantas especies de árboles como en Canadá y Estados Unidos. El parque Nacional Yasuní es hogar de la comunidad Huaorani y una de las comunidades indígenas que aún viven en aislamiento voluntario en la Amazonía, los Tagaeri-Taromenani, cuyas tierras ancestrales están sobre las reservas de petróleo más grandes del país, los campos de petróleo Ishpingo-Tambococha-Tiputini (ITT). El ITT tiene cerca de mil millones de barriles de petróleo, casi el 20 por ciento de las reservas totales del país.

En el 2007, el presidente Rafael Correa del Ecuador lanzó una propuesta histórica y sin precedente: Ecuador no permitiría la extracción de los pozos de petróleo del ITT en el Yasuní, si la comunidad internacional puede colaborar con la mitad de los ingresos que el país pierde por no explotar el petróleo. Si la iniciativa tiene éxito, se podrá dejar el petróleo permanentemente en la tierra y patrocinar así el futuro desarrollo sostenible del país.

Esta propuesta visionaria ayudaría a prevenir la deforestación tropical, la cual aporta entre 20 y 25 por ciento de los gases que causan el efecto invernadero, resultando en una reducción tangible y cuantificable de las emisiones de carbono al prevenir también el uso de los combustibles fósiles.

págs. 90-91 | *Grupos indígenas y partidarios, incluyendo al vicepresidente ecuatoriano Lenín Moreno, deletrean "Vive Yasuní" en el parque Nacional Yasuní, durante el lanzamiento de la campaña para salvar el parque del desarrollo petrolero.*

Kichwa boys read a school book at their home in Sarayaku with light provided by a newly installed solar power system.

Niños Kichwa, en su casa en Sarayaku, leen un libro escolar con luz generada por un nuevo sistema de energía solar.

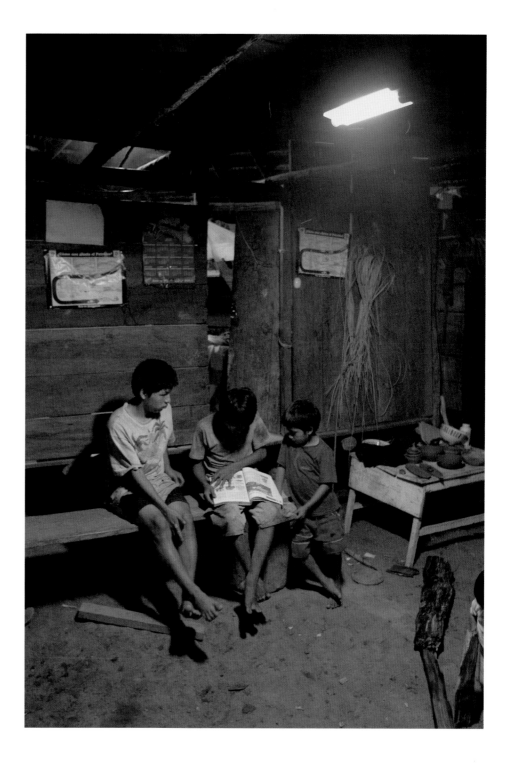

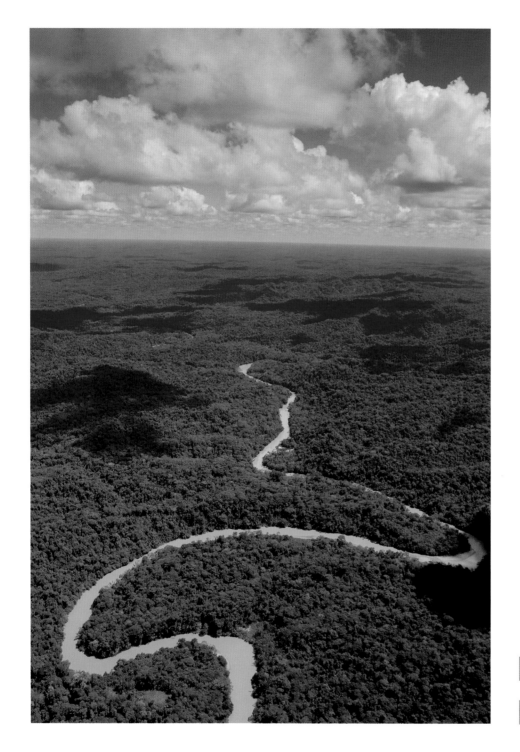

THE SOUTHERN AMAZON

The southern Ecuadoran Amazon boasts the country's largest surviving areas of primary tropical rainforest. Home to various indigenous groups, including the Shuar, Achuar and Kichwa peoples, this highly biodiverse region has been under threat from the oil industry for the past decade.

Southern Ecuadoran indigenous communities are aware of the destruction in the northern Amazon; this has fueled their opposition to oil drilling in their territories. They know that if their lands are opened up for oil exploitation, the rainforest will be crisscrossed by a network of roads and pipeline infrastructure that would pave the way for settlers, poachers and illegal loggers. In a short time, the rainforest on either side of these roads would be polluted, deforested or severely degraded, as has happened in numerous other areas of tropical rainforest around the world.

Indigenous groups and their partner organizations have begun advancing the "Green Plan", which lays out an alternative economic plan that coincides with the vision of indigenous stewardship of these globally significant tropical rainforests. The ultimate result of the Green Plan would be the creation of a permanently protected, indigenous-managed "Zona Intangible" (Untouchable Zone), where extractive industries are prohibited.

The Kichwa from Sarayaku, the Achuar, the Shuar and other communities in Ecuador's Amazon have joined with the Amazon Defense Front to form APAR—Alianza de los Pueblos Ancestrales en Resistencia—to fight for justice with those affected by Texaco in the northern Amazon and for the defense and conservation of their cultures and territories in the southern Amazon.

Aerial view of the Bobonaza River and surrounding rainforest near the Kichwa village of Sarayaku in the southern Amazon.

Vista aérea del Río Bobonaza y el bosque que lo rodea cerca de la comunidad Kichwa de Sarayaku en el sur de la Amazonía.

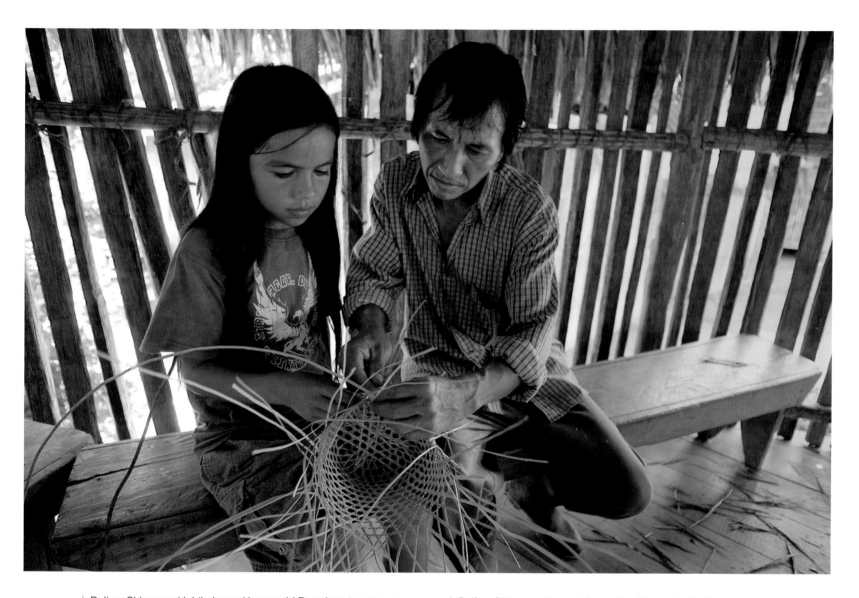

Bolivar Shiwango (right) shows 11-year-old Rasu how to weave a basket during an artisan class at Rasu's school in Sarayaku. The Kichwa teach their children basket weaving, ceramics and other artisan skills to make sure their cultural traditions continue into the future.

Bolívar Shiwango (derecha) enseña a Rasu, de 11 años, como tejer un canasto en una escuela en Sarayaku. Los Kichwa de Sarayaku enseñan a los niños a tejer canastos, hacer cerámicas y otras artes manuales para asegurarse que sus tradiciones culturales no se pierdan en el futuro.

Sabino Gualinga and daughter Patricia Gualinga

Kichwa Community of Sarayaku
Southern Amazon

Shaman Sabino Gualinga: When I was a child I used to go walking alone. On these walks I would never see people. There was nothing but animals and birds. This forest is sacred. Here we have pure air and flowers. It is a good life.

Patricia Gualinga: When the [oil company] isolated Sarayaku from the rest of the indigenous communities and began seismic exploration, I was in the city. One day, I spoke with two engineers, asking them about Sarayaku, and they responded: "Uh, no, we still haven't made it down there." And so I told them I had heard that the community of Sarayaku didn't allow oil companies in their territory. And they said: "Yes, but it won't be a problem because Sarayaku is just a mole in the forest. It doesn't mean much and won't put up much resistance." I said, "Be careful, it might be a cancerous mole."

Sabino Gualinga: When Shell arrived they began to cut trees and plants to construct a runway, without regard for the medicinal or commercial value of the forest. They felled medicinal trees, medicinal plants, as well as trees that we use for wood and canoes. After Shell, the other companies came.

Patricia Gualinga: Sarayaku has never believed in their promises. Sarayaku had already seen what had occurred in northern Ecuador with the oil companies there. It was a warning to us. And aside from this, Sarayaku has an intimate relationship with the world through our cosmology. So we began to think, what were the consequences of the oil drilling? What would happen to the creatures of the lakes and the mountains? What would happen to our daughters and our young men? All the consequences were negative, and so our indigenous assembly decided: "No. In Sarayaku territory, we will not allow oil drilling."

Sabino Gualinga: In this region that hasn't been developed yet there are lagoons and animals such as lizards, anacondas, boas and herons. There are two "mother lagoons" where there are fish. We have seen the destruction, and it's because of this that we won't accept the presence of oil companies here. Our future is our land, and we must take care of our natural resources.

Sabino Gualinga e hija Patricia Gualinga

Communidad Kichwa de Sarayaku
Amazonía Sur

Shamán Sabino Gualinga: Yo cuando pequeño me iba caminando solito, no había gente en ninguna parte, no había nada, puros animales, puros pájaros ahí. Es sagrada esa selva. Aquí tenemos aire puro, flores también, buena vida.

Patricia Gualinga: El primer enfrentamiento viene cuando ellos aíslan a Sarayaku completamente de todo lado y empiezan los trabajos de exploración sísmica. Entonces yo recuerdo que estaba en la ciudad y hablé con dos ingenieros. Y pregunté por Sarayaku. "Eh, todavía no hemos llegado. Entonces les dije, tengo entendido que la comunidad no acepta las petroleras." Y han dicho, "Sí, pero no es ningún problema porque es un lunar en la selva y no significa mayor resistencia." Y yo era de Sarayaku y les dije, "Cuidado, puede ser un lunar que tiene cáncer."

Sabino Gualinga: Cuando entró la Shell, construyeron una pista de aterrizaje y entonces se botaban árboles y plantas sin pensar, sin tener en cuenta su valor medicinal o comercial. Botaban palos medicinales, plantas medicinales, árboles para maderas, árboles para canoas. De ahí vinieron otras compañías.

Patricia Gualinga: Sarayaku nunca ha creído en las promesas. Sarayaku había ya visto lo que ocurrió en el norte de Ecuador con las empresas petroleras y lo que había pasado allá fue un aviso. Y aparte de eso Sarayaku tiene una estrecha relación con su mundo a través de la cosmovisión. Entonces se pusieron a medir las consecuencias del petróleo, que pasaría, que pasaría con los seres que están en los lagos, en las montañas, que consecuencias traería con las hijas, con los jóvenes y en realidad el análisis que se hizo dio resultados muy negativos y la asamblea decidió que no. En territorio Sarayaku, no dejó la explotación petrolera.

Sabino Gualinga: En esta parte que aún no está trabajada hay lagunas, animales como lagartos, anacondas, boas y muchas garzas. Hay dos lagunas madre donde sí hay pescado. Nosotros hemos visto la destrucción y es por eso que no aceptamos aquí a las compañías petroleras. El futuro es nuestra tierra y debemos cuidar los recursos naturales.

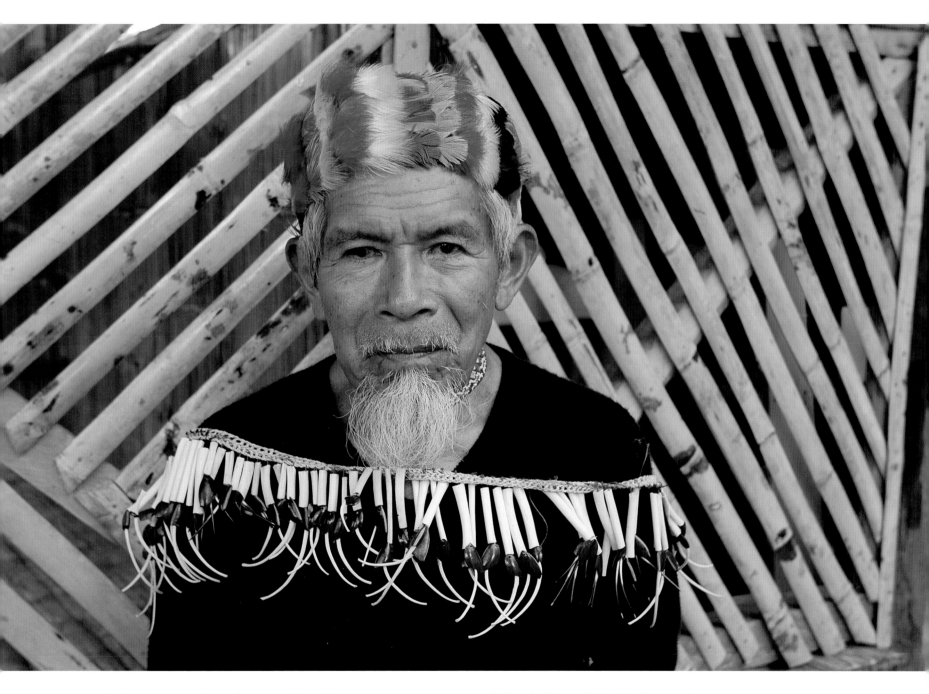

| Kichwa shaman Sabino Gualinga in Sarayaku. | Shamán Kichwa, Sabino Gualinga, en Sarayaku.

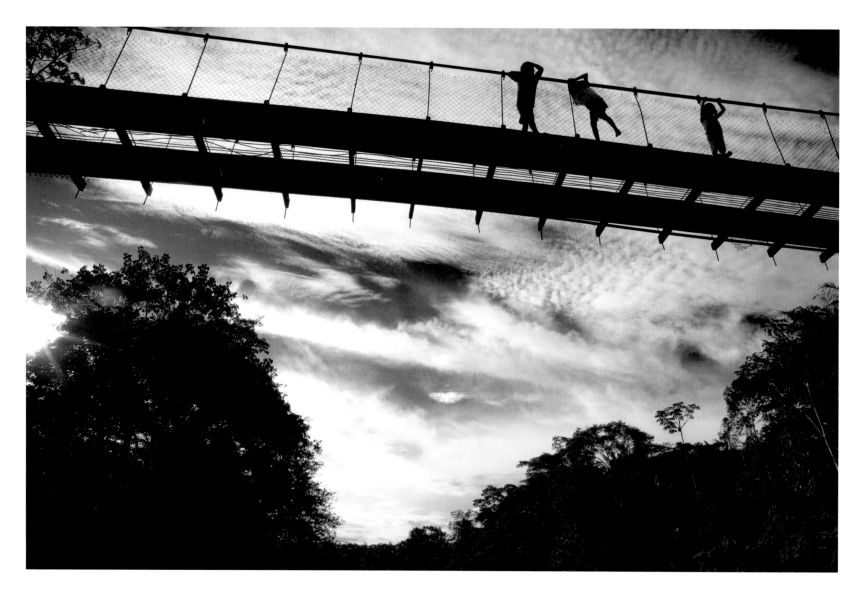

| Kichwa children on a bridge over the Bobonaza River in Sarayaku. | Niños Kichwa en un puente sobre el Río Bobonaza en Sarayaku.

EL SUR DE LA AMAZONÍA

El sur de la Amazonía ecuatoriana es la más grande reserva de bosque primario tropical sobreviviente en el país. Esta zona alberga varios grupos indígenas incluyendo a los pueblos Shuar, Achuar y Kichwa, contiene una gran biodiversidad y ha estado bajo la amenaza de la industria petrolera en la última década.

Las comunidades indígenas del sur del Ecuador están conscientes de la destrucción en el norte de la Amazonía; lo que ha impulsado su firme oposición a las operaciones petroleras en sus territorios. Saben que si la región se abre a la explotación petrolera, la selva tropical será cruzada por una red de carreteras y oleoductos que daría paso para que colonos, cazadores, taladores de árboles y otros forasteros la penetren. En corto tiempo, el bosque tropical alrededor de los caminos sería contaminado, deforestado o degradado, como en vastas zonas de selva tropical alrededor del mundo.

Grupos indígenas de la región y organizaciones aliadas han iniciado el "Plan Verde," que es una propuesta económica alternativa que coincide con la visión de las comunidades indígenas de guardianes de esta selva que tiene importancia global. El resultado del Plan Verde sería la creación de una "Zona Intangible," un área protegida, manejada por las comunidades indígenas, donde las industrias extractivas estén prohibidas.

Los pueblos Kichwa de Sarayaku, los Achuar, Shuar y otras comunidades en la Amazonía ecuatoriana se han unido al Frente de Defensa de la Amazonía para formar APAR —Alianza de los Pueblos Ancestrales en Resistencia— que tiene como finalidad luchar por la justicia de los afectados por Texaco en el nororiente y defender las culturas y territorios en el suroriente.

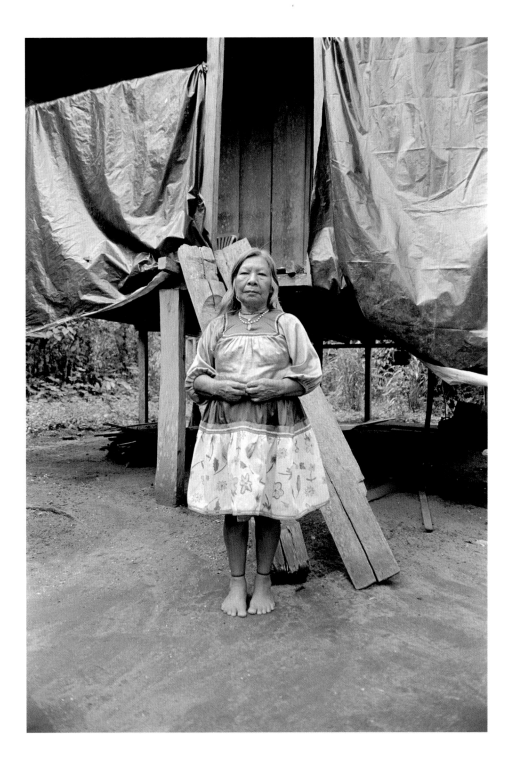

Cofan elder outside of her home in Dureno.

Anciana Cofán fuera de su casa en Dureno.

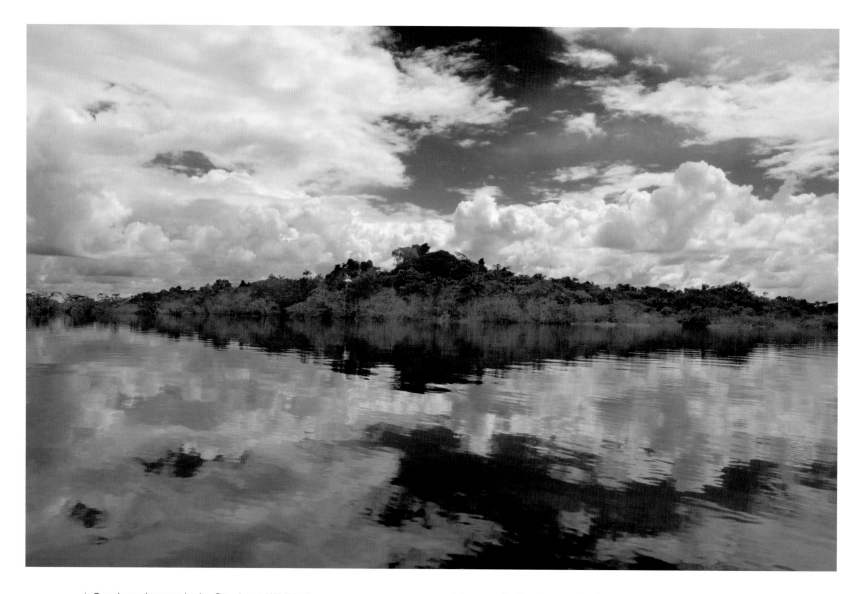

Cuyabeno Lagoon in the Cuyabeno Wildlife Reserve.　　Laguna de Cuyabeno en la Reserva Natural de Cuyabeno.

Cofan woman and boy looking out a window of their home in Dureno.

Mujer y niño Cofán mirando desde una ventana en su casa en Dureno.

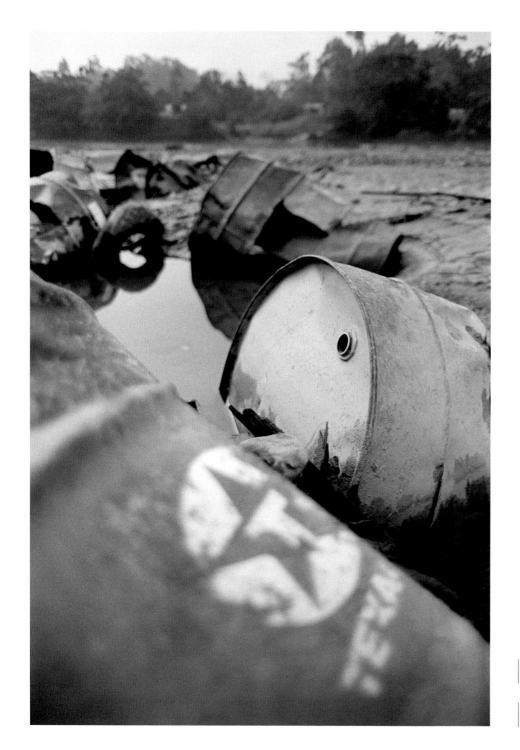

Old Texaco oil barrels left on the banks of the Aguarico River near Lago Agrio.

Barriles obsoletos de Texaco, abandonados a orillas del Río Aguarico cerca de Lago Agrio.

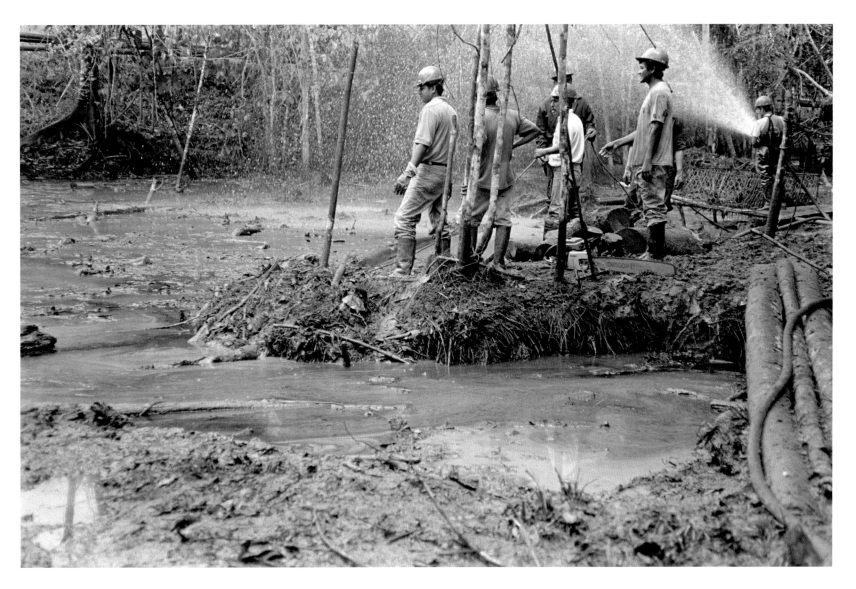

Oil spill cleanup effort next to the PetroEcuador North Sacha Station.

Trabajo de limpieza de un derrame de petróleo cerca de la Estación Sacha Norte de PetroEcuador.

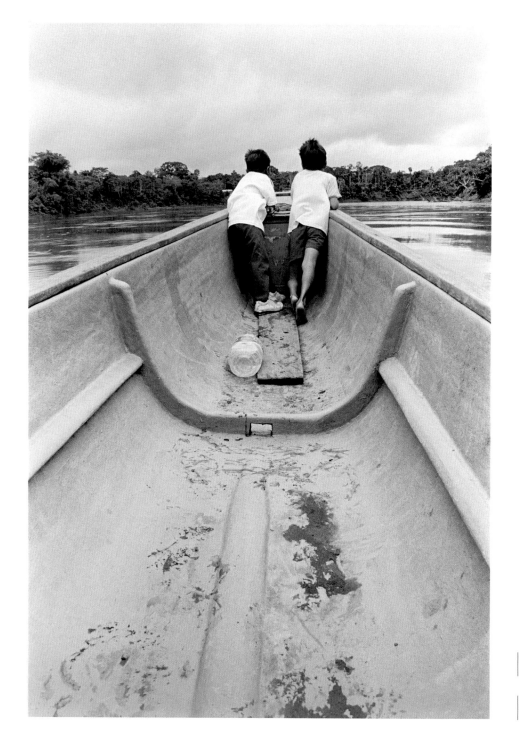

"Our struggle is not for money. We want you to repair the damage so our children do not have to continue suffering."

—SECOYA LEADER HUMBERTO PIAGUAJE, speaking to shareholders at the 2007 Chevron shareholders meeting.

"*Nuestra lucha no es por dinero. Queremos que reparen los daños para que nuestros hijos no tengan que seguir sufriendo.*"

—LIDER SECOYA LEADER HUMBERTO PIAGUAJE, dirigiendose a los accionistas durante la asamblea general de Chevron en el 2007.

Cofan boys traveling down the Aguarico River on their way to Dureno.

Niños Cofanes se desplazan por el Río Aguarico en su camino a Dureno.

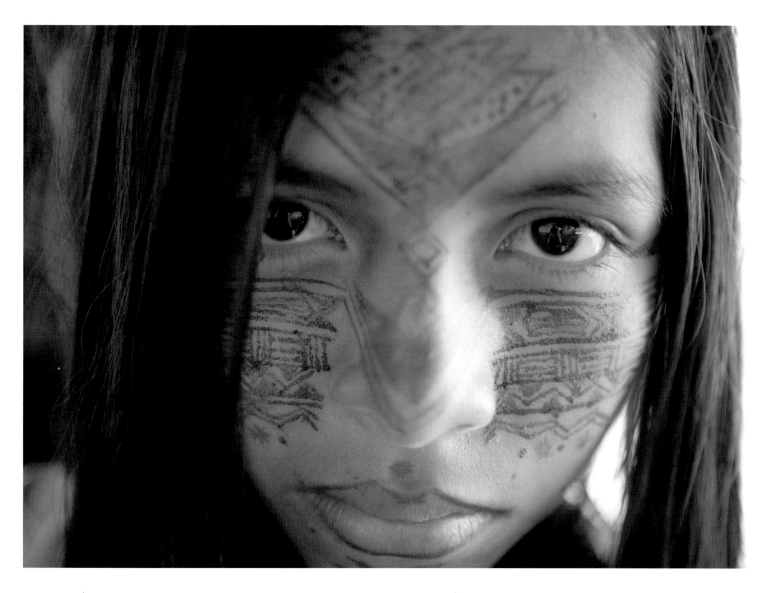

Kichwa girl with traditional face paint in Sarayaku.

Niña Kichwa con su cara adornada con pintura tradicional en Sarayaku.

pgs. 106-107 | *Jatuncocha Lagoon in Yasuni National Park.*
págs. 106-107 | *Laguna Jatuncocha en el Parque Nacional Yasuní.*

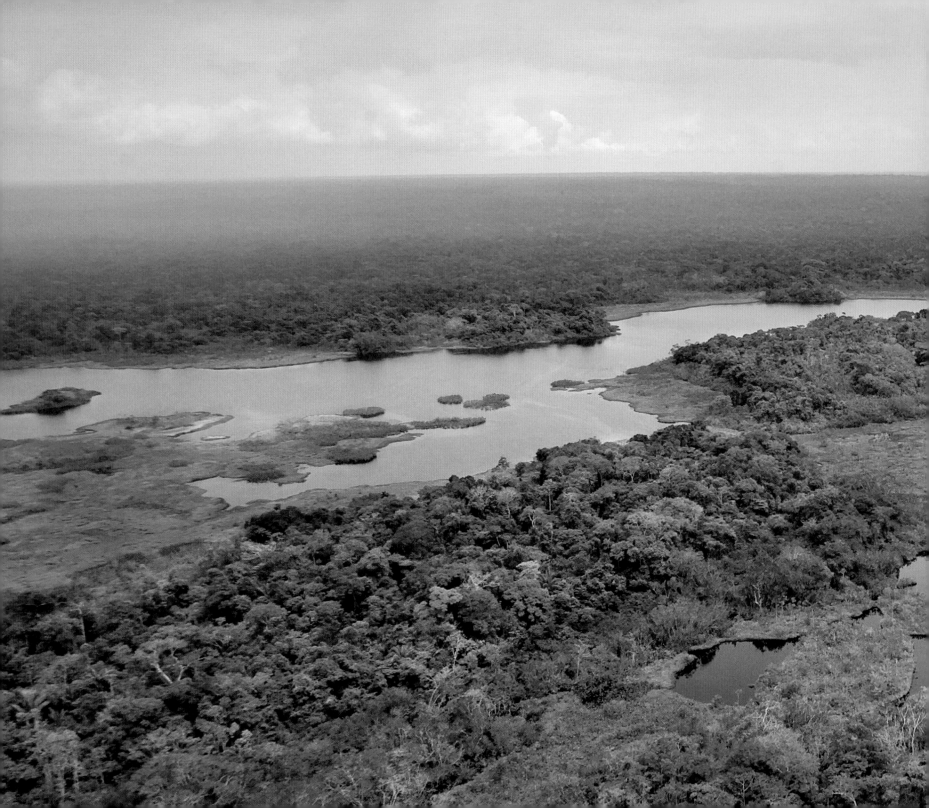

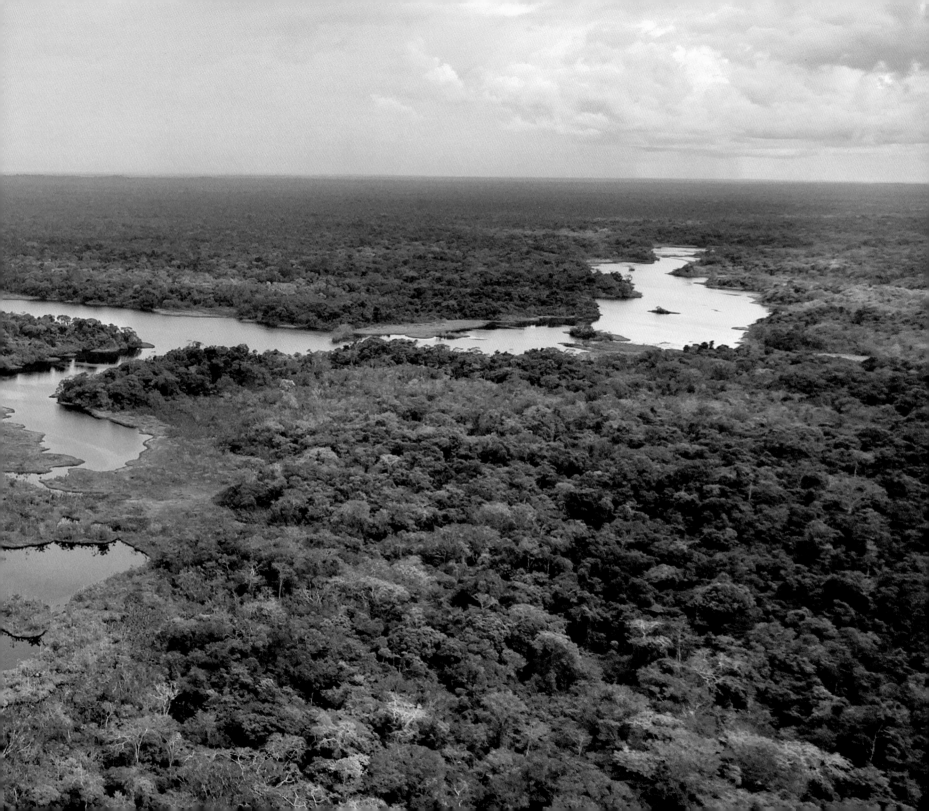

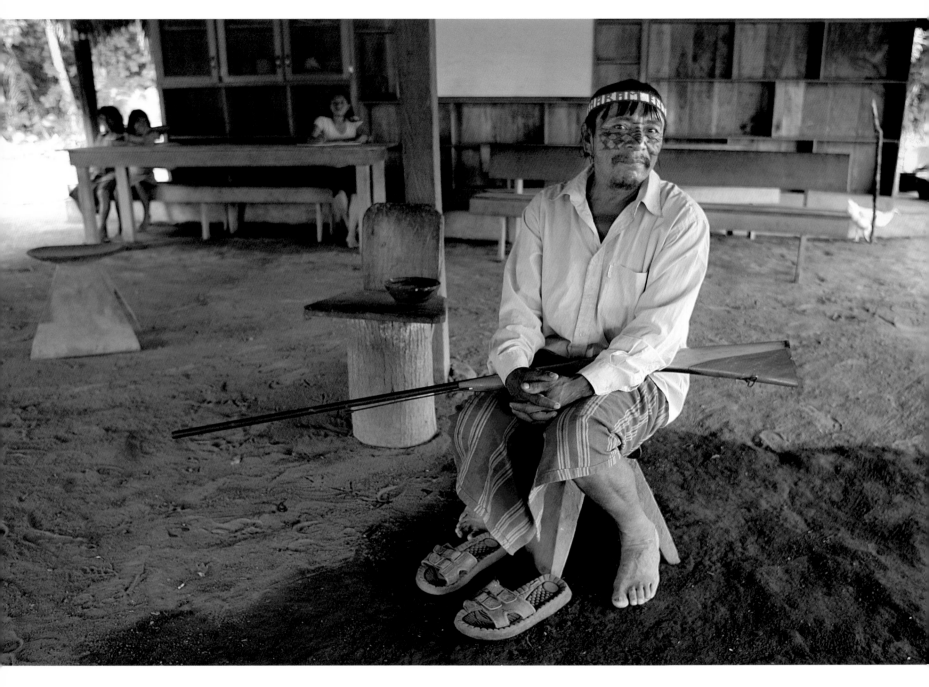

| Felipe Tentets, elected leader of the Achuar village of Sharamentza. | Felipe Tentets, síndico de la comunidad Achuar de Sharamentza.

Felipe Tentets, Nampichka Pitiu and Jorge Canelos

Achuar Community of Sharamentza
Southern Amazon

Felipe Tentets (elected community leader): The problems began during the presidency of Lucio Gutierrez because he wanted to send the oil companies to our territory. Since then, it's been an issue that we have fought against a lot and we will continue to fight it.

We, the Achuar people, want to live in peace and freedom. When [oil] companies enter our territory, they change our culture.

There are other indigenous groups that have changed their culture. Now they live in cities. We don't want to live in cities but here in our own territory. We don't want to change our language or our way of dressing. Nor do we want our daughters to change. We don't want them to leave and to begin copying the west; we don't want them to begin prostitution and to bring back diseases from other places. This is the type of change that we don't want.

Nampichka Pitiu: I am going to speak as an Achuar woman. I have heard that this oil company says it wants to come here and take away all of the oil from our land. We don't want them to do that; we don't want oil companies to come here to destroy us and displace us.

I, as an Achuar woman, want to say that my grandchildren are the ones that are going to live after I die. For them, I ask that we don't turn over our lands to the oil company. As an Achuar woman of my age, I say: we will never let this happen, we will be firm defending our land until death.

Jorge Canelos: We don't want roads and highways because roads bring settlers, timber companies, mining companies, and other companies. I want the world to know that the Achuar people are ready to develop ourselves here, in our own lands, to take care of the forest and our earth. I also would like to tell the transnational companies that go around asking for oil from the indigenous peoples, "We don't want you to do this." One can't keep thinking about taking petroleum out of the ground. This is the blood of the earth, and we are never going to allow it to be taken out. The Achuar people will stand firm and fight until death.

Síndico Felipe Tentets, Nampichka Pitiu y Jorge Canelos

Comunidad Achuar de Sharamentza
Amazonía Sur

Síndico Felipe Tentets: Desde el tiempo del presidente Lucio Gutiérrez, empezaron los problemas, porque él quería mandar a los petroleros a nuestro territorio y desde esa época este es un tema que hemos peleado bastante y que seguiremos peleando.

Nosotros, el pueblo Achuar, queremos vivir libres y en paz. Cuando las compañías [petroleras] entran a nuestro territorio, cambian nuestra cultura.

Hay otras nacionalidades que cambiaron su cultura, ahora viven en ciudad. Nosotros no queremos vivir en ciudades sino aquí en nuestro propio territorio. No queremos cambiar el idioma, ni la manera de vestir. Tampoco queremos el cambio de nuestras hijas, que salen afuera a hacerse copia del occidente, hacen prostitución y también traen otras enfermedades de otras nacionalidades. Eso es el cambio que no puede ser así.

Nampichka Pitiu: Yo voy a hablar como mujer Achuar. He escuchado que esta compañía petrolera dice que quiere venir a sacar todo el crudo de nuestra tierra. Nosotros no queremos que hagan eso, no queremos que las compañías petroleras vengan acá a destruir y a despojarnos.

Yo como mujer Achuar quiero decir que son mis nietas y nietos, los que van a vivir cuando yo muera. Por ellos yo pido que no entreguemos nuestro territorio a la compañía petrolera, nosotros no queremos eso. Como mujer Achuar de esta edad digo que esto jamás lo permitiremos. Estaremos firmes defendiendo nuestra tierra hasta morir.

Jorge Canelos: No queremos carreteras porque las carreteras llegan y traen colonización, compañías madereras, mineras y otras compañías.

Quiero que el mundo sepa que el mundo Achuar está dispuesto a desarrollarse aquí en su mismo sitio para cuidar a la selva y nuestra tierra. También quisiera decirle a las empresas transnacionales que andan pidiendo petróleo al pueblo indígena, que no quisiéramos que hagan esto. No solamente se puede pensar en sacar petróleo de la tierra, ese es la sangre de la tierra y eso no lo vamos a permitir, jamás. El pueblo Achuar tendrá la firmeza y luchará hasta su muerte.

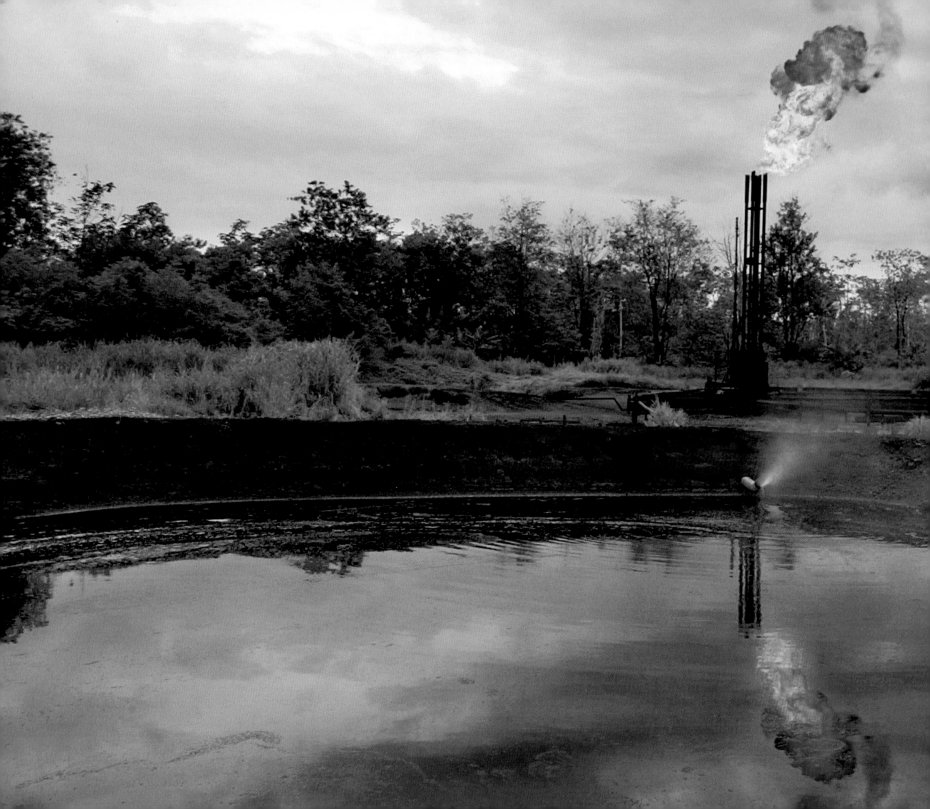

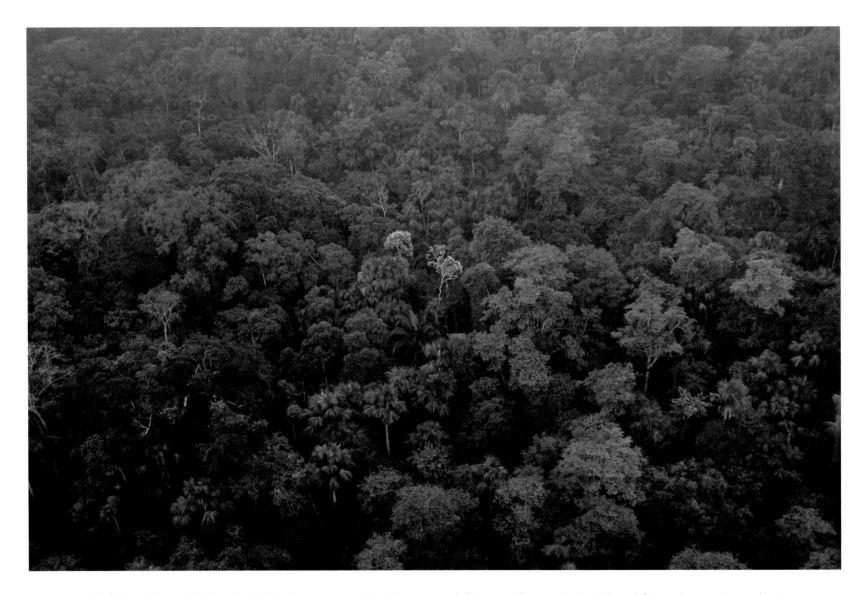

Rainforest in Yasuni National Park. Nearly as many species of trees are found in 2.5 acres of the Yasuni rainforest as the total number of tree species found in the United States and Canada combined.

Selva en el Parque Nacional Yasuní. Se puede encontrar casi tantas especies de árboles en una hectárea de Yasuní como el número total de especies existentes en Canadá y Estados Unidos juntos.

pgs. 110-111 | Gas is burned off at a separation station built by Texaco outside the town of Shushufindi.
págs. 110-111 | Quema de gas en una estación de separación construida por Texaco, en las afueras de Shushufindi.

| Achuar boy in Tsunkintsa in the southern Amazon.

| Niño Achuar en Tsunkintsa al sur de la Amazonía.

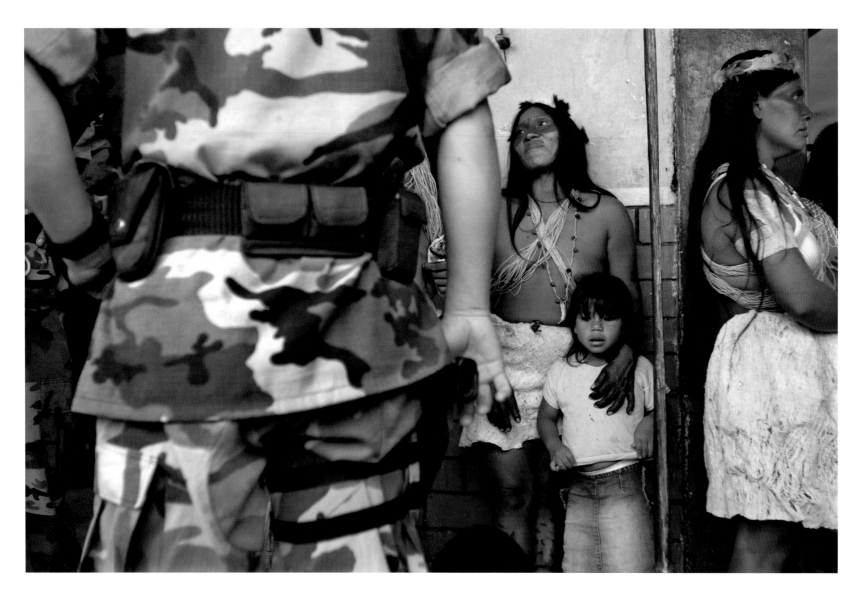

A member of the Ecuadoran special forces keeps an eye on Huaorani women before the start of a march against Chevron (formerly Texaco) in Lago Agrio.

Un miembro de las fuerzas especiales ecuatorianas vigila a las mujeres Huaorani, antes que iniciaron una marcha en contra de Chevron (antes Texaco) en Lago Agrio.

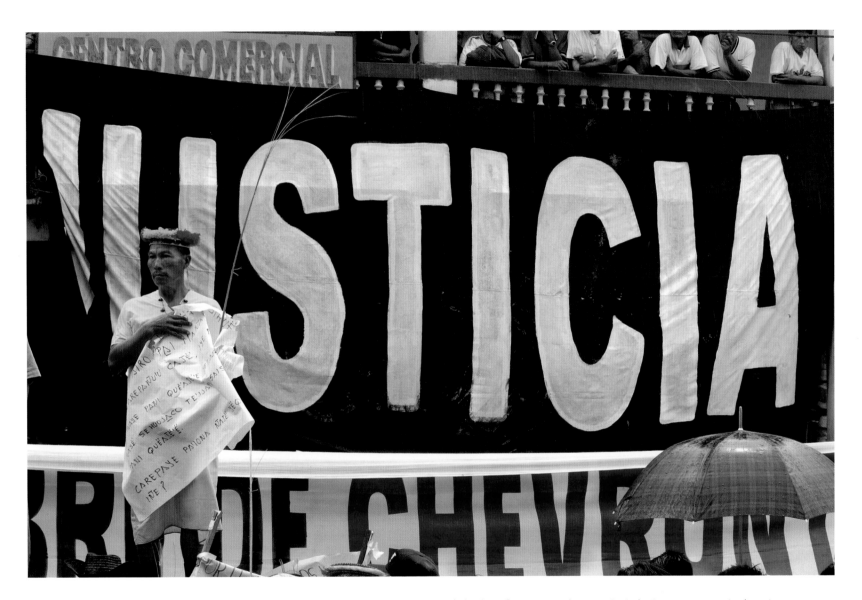

A Secoya elder stands in front of a banner reading "Justice" during a demonstration at the start of the trial against Chevron (formerly Texaco) in Lago Agrio.

Anciano Secoya parado en protesta junto a una pancarta durante la manifestación realizada al inicio del juicio contra Chevron (antes Texaco) en Lago Agrio.

pgs. 116-117 | *View of the Pastaza River from Sharamentza with the Sangay volcano in the background. It's eastern slope is the beginning of the Amazon basin.*
págs. 116-117 | *Vista del Río Pastaza desde Sharamentza, con el volcán Sangay atrás. La ladera este del volcán es donde comienza la cuenca Amazónica.*

REPÚBLICA DEL ECUADOR

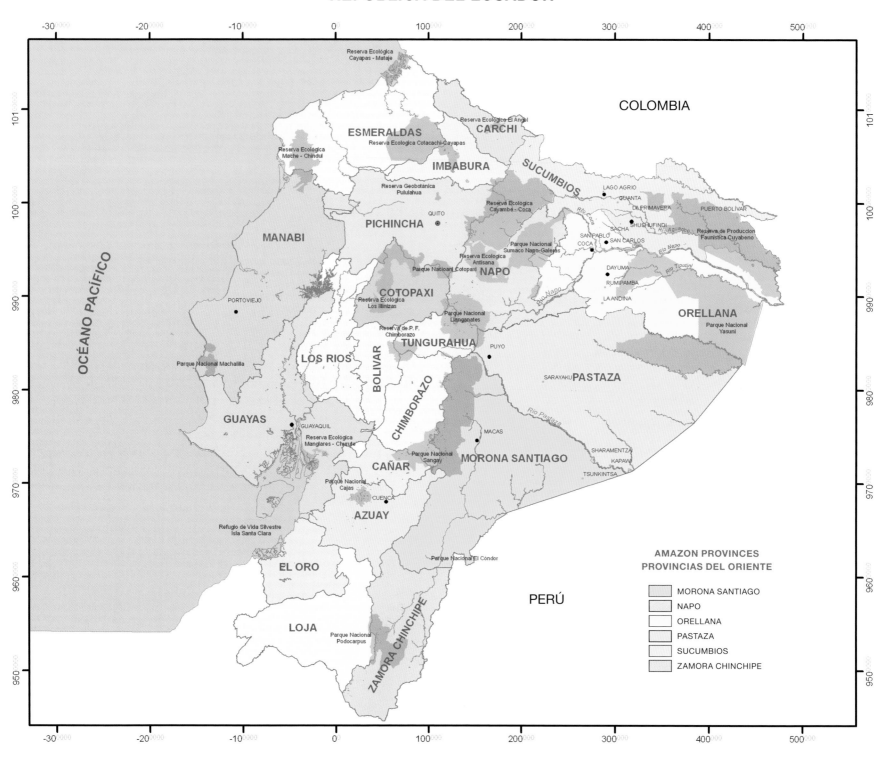

COLOMBIA

OCÉANO PACÍFICO

Reserva Ecológica
Cayapas - Mataje

Reserva Ecológica El Ángel

ESMERALDAS

CARCHI

Reserva Ecológica Cotacachi-Cayapas

Reserva Ecológica
Mache - Chindul

IMBABURA

SUCUMBIOS

Reserva Geobotánica
Pululahua

LAGO AGRIO

GUANTA

Reserva Ecológica
Cayambé - Coca

LA PRIMAVERA

PUERTO BOLÍVAR

QUITO

PICHINCHA

Río Coca

SHUSHUFINDI

Río Aguarico

SACHA

MANABI

SAN PABLO

COCA

SAN CARLOS

Reserva de Producción
Faunística Cuyabeno

Parque Nacional
Sumaco Napo-Galeras

Río Napo

Reserva Ecológica
Antisana

DAYUMA

Río Tiputini

Parque Nacional Cotopaxi

NAPO

RUMIPAMBA

PORTOVIEJO

Río Napo

COTOPAXI

LA ANDINA

Reserva Ecológica
Los Illinizas

Parque Nacional
Llanganates

ORELLANA

Parque Nacional
Yasuní

Reserva de P.F.
Chimborazo

TUNGURAHUA

PUYO

LOS RIOS

Parque Nacional Machalilla

BOLIVAR

SARAYAKU

PASTAZA

CHIMBORAZO

Río Pastaza

GUAYAS

GUAYAQUIL

MACAS

Reserva Ecológica
Manglares - Churute

Parque Nacional
Sangay

SHARAMENTZA

MORONA SANTIAGO

KAPAWI

CAÑAR

TSUNKINTSA

Parque Nacional
Cajas

CUENCA

AZUAY

Refugio de Vida Silvestre
Isla Santa Clara

Parque Nacional El Cóndor

PERÚ

EL ORO

LOJA

Parque Nacional
Podocarpus

ZAMORA CHINCHIPE

AMAZON PROVINCES
PROVINCIAS DEL ORIENTE

MORONA SANTIAGO
NAPO
ORELLANA
PASTAZA
SUCUMBIOS
ZAMORA CHINCHIPE

epilogue *by Atossa Soltani*

The majestic tropical rainforests of the Amazon basin cover an area larger than the continental United States. Upwards of one-third of the planet Earth's species are found in the Amazon, making it an unparalleled repository of biodiversity. For example, in 2.5 acres of pristine rainforest in northeastern Ecuador, there are as many tree species as are found in all of North America.

Nearly one-fifth of the world's fresh water is generated in the Amazon basin. The Amazon River is fed by over 1,100 tributaries, of which 17 are longer than 1,000 miles. Finally, given that half of every tree is comprised of carbon, the region serves as a "sink" for billions of tons of carbon, sequestered within three million square miles of thick forest and vegetation. Consider that one-quarter of all modern pharmaceuticals are derived from plants in the rainforest, from an area covering less than 7 percent of the earth's surface. Currently, less than 1 percent of rainforest plants have been studied for their medicinal properties.

Indigenous cultures in the Amazon often call their homeland the "heart" of the world. As the "heart", the Amazon rainforest serves as a massive engine pumping hot air and vapor that helps feed trade winds and drive wind and rainfall around the planet. Simply put, the Amazon rainforest is a vital part of the life-support system of our planet. Unfortunately, the Amazon rainforest is being destroyed at the alarming rate of seven football fields per minute. The destruction is happening at such an unprecedented rate that these forests could disappear by the end of this century, with devastating consequences for plants, animals and our very own existence.

The entire system is now at risk of collapse, reaching ever closer to the "tipping point" which, some scientists predict, could turn the Amazon into a vast savanna by the end of this century. Should this occur, all of the region's billions of tons of carbon would have literally gone up in smoke, increasing the rate at which the planet warms.

Extractive industries seeking oil, minerals and timber are fragmenting, polluting and destroying a vital global treasure and threatening millions of people who inhabit the region. Oil, gas and coal extraction in the Amazon carry a double-edged sword for global warming: The end product, the oil, gas or coal, eventually releases carbon stored in the earth into the atmosphere. In addition, forests are cut down and degraded. Access roads for mines, pipelines and oil operations are then exploited by logging interests—legal and illegal—in addition to waves of settlers who use the roads to land-grab and begin a process of slash and burn. In the end, carbon from both above and below ground (the felled trees, the burning of forests and the oil reserves) contributes to worsening the greenhouse effect.

The prospect of these long-term global impacts is horrifying. But the short-term local consequences are similar cause for concern. Many of the region's 400 indigenous peoples depend on the forest for their immediate survival. They are the first to feel the full force of environmental destruction and associated violations of their individual and collective rights.

This book illustrates the dynamics of destruction in just one corner of the Amazon basin, in northeastern Ecuador, known to Ecuadorans as the *Oriente*. The battle for environmental justice and accountability from oil companies, principally Chevron (formerly Texaco), in Ecuador is both precedent-setting and emblematic.

Amazonian indigenous communities, however, aren't passively watching their territories be destroyed and their rights trampled. Across the region they are engaging in organized struggles against governments and transnational corporations in defense of their lands and culture.

Thirty-some years ago, Texaco (now Chevron) executives in New York made a decision to drill and dump, and pollute the Amazon rainforest. Their oil concession fragmented and poisoned the territories of the Cofan, Siona, Secoya, Huaorani and Kichwa indigenous peoples, who for the most part had been living traditionally on their ancestral territories, and their lives were violently disrupted. These communities continue their determined struggle for

cultural survival and recuperation of their lands, language, culture and way of life. Joining together and with non-indigenous forest communities, more than 30,000 people are part of the class-action lawsuit against Chevron calling for environmental remediation, potable water and medical care.

Just to the South of Texaco's oil operations, vast areas of the Ecuadoran Amazon remain roadless and intact. There, some 80,000 indigenous people from the Shuar, Achuar, Kichwa, Zapara, and Shiwiar indigenous communities continue to live traditionally in some of the last pristine areas of the Ecuadoran Amazon. Having witnessed the horrid history of oil companies to their north, the indigenous communities in southern Ecuador have steadfastly resisted oil exploitation. Since the mid-1990s, these communities have successfully blocked the entry of oil companies. First Arco, then Burlington, then ConocoPhillips have failed to realize their oil exploration activities. Through lawsuits, nonviolent resistance, land titling and international alliances, these communities have successfully defended their rights and their territories.

Ecuadoran indigenous groups in both northern and southern Ecuador have emerged as inspiring leaders in these struggles, scoring victories against seemingly insurmountable odds. Given that our future survival is inextricably linked to the fate of the rainforest, indigenous peoples' struggles are not just for their own future survival, but are truly in service to all of humanity.

In a hopeful turn of events, President Rafael Correa took office in Ecuador in January 2007 and temporarily suspended auctions for new oil concessions in the southern Ecuadoran Amazon. President Correa also put forth an innovative proposal to keep the country's largest oil reserves in the ground forever while protecting the forests above. The Yasuni National Park is one of the most biodiverse areas of rainforest found within the Amazon basin. It is also home to the Tagaeri-Taromenani, some of the last isolated indigenous peoples of the Amazon. Directly beneath the park is Ecuador's largest oil reserve, holding nearly one billion barrels of oil, roughly 20 percent of the country's reserves. President Correa has offered a reprieve for the Yasuni National Park by offering to forgo developing these oil fields, and has asked the international community to provide financial compensation in return, such as debt relief, bilateral aid and public contributions. This visionary proposal would prevent tropical deforestation and result in tangible and quantifiable reductions in carbon emissions from not burning fossil fuels. It would put the country on a clean energy path and make it a role model to emulate.

The fate of the Amazon is in the world's hands and in the hands of every one of us. Concerned citizens around the world need to take action to hold companies like Chevron accountable, support peoples' struggles for their rights and reparations, and support bold initiatives like President Correa's Yasuni plan to compensate countries for conserving their rainforests.

We are the last generation with the power to save the Amazon rainforest. Future generations depend on our actions today for a livable world tomorrow.

ATOSSA SOLTANI IS THE FOUNDER AND EXECUTIVE DIRECTOR OF AMAZON WATCH.

epílogo *por Atossa Soltani*

La majestuosa selva de la cuenca Amazónica cubre un área más extensa que la de los Estados Unidos. Más de la tercera parte de las especies del planeta pueden ser encontradas en la Amazonía, lo que la hace un incomparable refugio de biodiversidad. En una hectárea de selva prístina del nororiente ecuatoriano, existen más especies de árboles que en todo Norte América.

Aproximadamente la quinta parte de agua dulce en el mundo proviene de la cuenca Amazónica. El Río Amazonas tiene más de 1,100 afluentes, de los cuales 17 tienen una extensión de más de 1,000 millas. Además, debido a que la mitad de cada árbol está compuesta de carbono, esta región sirve como depósito de miles de millones de toneladas de carbono, capturadas en un área de tres millones de millas cuadradas de bosque y vegetación. Un cuarto de los productos farmacéuticos modernos son derivados de plantas de la selva tropical, de un área que cubre menos del siete por ciento de la superficie de la tierra. Actualmente las propiedades medicinales de menos del uno por ciento de las plantas provenientes de la selva tropical han sido estudiadas.

Las culturas indígenas amazónicas conocen a sus territorios como "el corazón de la tierra". Como el corazón, la selva amazónica cumple la función de motor que bombea aire caliente y vapor que sirve para alimentar los vientos alisios que conducen las corrientes de aire y lluvia alrededor del planeta. Puesto de manera simple, la selva amazónica es elemento vital del sistema de apoyo del planeta. Desafortunadamente, la selva amazónica está siendo devastada de manera alarmante, a una tasa de siete campos de fútbol por minuto; una destrucción a ritmo sin precedentes, de manera tal que estos bosques podrían desaparecer antes de finalizar este siglo, lo que traería consecuencias funestas para las plantas, los animales y nuestra propia existencia.

El sistema completo está en riesgo de colapsar en este momento, estamos cada vez más cerca al "punto de no retorno" cuando, predicen algunos científicos, la Amazonía podría convertirse en una vasta sabana para el final de este siglo. Si esto llegara a suceder, todos los miles de millones de depósitos de carbono que se encuentran en esta región literalmente se volverían humo, aumentando así el calentamiento global.

Las industrias extractivas en busca del petróleo, minerales y madera están fragmentando, contaminando y destruyendo un tesoro global y poniendo en riesgo a millones de personas que habitan la región. La extracción de petróleo, gas y carbón en la Amazonía es un arma de doble filo para el calentamiento global: el producto final, gas, petróleo o carbón, eventualmente emite carbono a la atmósfera. Adicionalmente, los bosques son cortados y degradados. Las vías de acceso a las minas, los oleoductos y las operaciones de la industria petrolera están siendo usadas también por la industria maderera—legal e ilegal—además de las olas de colonos que usan estas mismas vías de acceso para apropiarse de terrenos y empezar la práctica de corte y quema. Finalmente, el carbono que se libera de la superficie y el subsuelo de la tierra (los árboles talados, la quema de bosques y las reservas de petróleo) está contribuyendo a empeorar el efecto invernadero.

La perspectiva de estos impactos globales a largo plazo es espeluznante. Pero las consecuencias a corto plazo a nivel local son también preocupantes. Muchos de los 400 pueblos indígenas de la región dependen directamente de la selva para su supervivencia. Estos pueblos son los primeros en sufrir las consecuencias de la destrucción ambiental y la violación de sus derechos individuales y colectivos a consecuencia de esta destrucción.

Este libro ilustra la dinámica de destrucción en sólo una esquina de la Amazonía, en la región del nororiente de Ecuador; y la batalla para que las compañías petroleras, principalmente Chevron (antes Texaco), asuman su responsabilidad. Esta lucha por la justicia ambiental en Ecuador fija un precedente y es además emblemática.

Las comunidades indígenas de la Amazonía no están mirando pasivamente la destrucción de sus territorios, ni el abuso en contra de sus derechos. A través de toda la región se están organizando luchas contra los gobiernos y las corporaciones transnacionales para defender su cultura y su territorio.

Hace más de treinta años, las directivas de Texaco (actualmente Chevron) en Nueva York decidieron perforar y luego botar sus desechos, contaminando la selva Amazónica. Las concesiones petroleras fragmentaron y envenenaron los territorios de las nacionalidades indígenas Cofán, Siona, Secoya, Huaorani y Kichwa, que habitaban en sus territorios ancestrales y cuyas vidas fueron trastornadas de manera violenta. Estas comunidades continúan su decidida defensa por la supervivencia de su cultura y la recuperación de sus territorios, su lengua y su modo de vida. Uniéndose entre ellos y con grupos no indígenas que también habitan la región, más de 30.000 personas son parte de la demanda colectiva en contra de Chevron que busca una remediación ambiental, agua potable y atención médica.

Justo al sur de las zonas de operaciones petrolíferas de Texaco, en la Amazonía sur del Ecuador, existen vastas áreas que permanecen intactas. Hay alrededor de 80,000 indígenas de las nacionalidades Shuar, Achuar, Kichwa, Zapara y Shiwiar que continúan viviendo de manera tradicional en las últimas áreas vírgenes de la Amazonía Ecuatoriana. Después de haber sido testigos de las horrendas historias de las compañías petroleras en el norte, las comunidades indígenas del sur de Ecuador han mantenido una firme resistencia a la explotación petrolera, impidiendo con éxito su ingreso, desde mediados de los noventa. Primero Arco, luego Burlington y por último ConocoPhillips han fracasado en su intento de explotar petróleo en su territorio. A través de demandas, resistencia no violenta, titulación de sus territorios y alianzas internacionales, han logrado defender sus derechos y sus territorios.

Los pueblos indígenas del Ecuador, tanto en el norte como en el sur, han surgido como inspiradores líderes de estas luchas, obteniendo victorias ante situaciones adversas que parecían difíciles de superar. Dado que nuestra futura supervivencia está indudablemente ligada al futuro de la selva tropical, la lucha que estos pueblos indígenas libran, no es solamente por su propia vida, sino también una oportunidad para toda la humanidad.

En un cambio de dirección prometedor, el presidente Rafael Correa asumió el poder en Ecuador, en enero del 2007 y suspendió temporalmente la entrega de nuevas concesiones de petróleo en la Amazonía. El presidente Correa también lanzó una iniciativa, una propuesta innovadora para mantener la reserva más grande de petróleo del país en el subsuelo para siempre y proteger así la selva. El parque Nacional Yasuní es una de las áreas con mayor biodiversidad de selva húmeda de la cuenca Amazónica. También es el hogar de los Tagaeri y Taromenani, unas de las últimas comunidades indígenas aisladas de la Amazonía. Bajo el suelo del parque se encuentra la más grande reserva de petróleo de Ecuador, con más de mil millones de barriles de crudo, casi el 20 por ciento de las reserves nacionales. El presidente Correa ha ofrecido una moratoria para el Yasuní; ha ofrecido no extraer estas reservas petroleras a cambio de una compensación económica solicitada a la comunidad internacional, como alivio de la deuda externa, cooperación bilateral y contribuciones públicas. Esta visionaria propuesta evitaría la deforestación tropical, con una reducción tangible y cuantificable de las emisiones de carbono. Esto pondría al país en un camino hacia la energía limpia y lo convertiría en un modelo a seguir.

El destino de la Amazonía está en manos del mundo y en las manos de cada uno de nosotros. Personas preocupadas alrededor del planeta necesitan tomar acciones y exigir a compañías como Chevron que se responsabilicen por sus actos; además apoyar la lucha de las personas para defender sus derechos, presionar para que se cumpla la reparación y apoyar las valientes iniciativas como el plan Yasuní, que contempla compensar a los países por conservar sus bosques tropicales.

Somos la última generación con el poder de salvar la selva Amazónica. Para contar con un mundo habitable, las futuras generaciones, dependen de las acciones que tomemos hoy.

ATOSSA SOLTANI ES LA FUNDADORA Y DIRECTORA EJECUTIVA DE AMAZON WATCH.

reflections *by Pablo Guayasamin*

In June of 2007, the Guayasamin Foundation presented to the Ecuadoran public a powerful photographic exhibit titled *Crude Reflections,* the impact of which has reverberated beyond Ecuador's borders. Through the magical lenses of Lou Dematteis and Kayana Szymczak, *Crude Reflections*, at first an exhibit and now a book, captures the destructive human and ecological effects caused by Texaco (now Chevron), an oil company that operated in the Ecuadoran Amazon region from 1964 to 1992. The photographic exhibition reveals the environmental neglect, disease and suffering caused by destructive oil extraction processes to the people of the Orellana and Sucumbios regions and to the planet itself.

Crude Reflections represents a human and environmental cry of pain and desperation from the remotest regions of the Amazon. Words are not needed to convey the urgency of the situation, as well as the legitimate right the people of the Orellana and Sucumbios regions have to demand that their claims be recognized, acknowledged and mitigated by those who are responsible.

How can you ever compensate the people for the loss of life and the suffering that the destruction of the local ecosystem has caused? The indigenous peoples and other residents of the Amazon are seeking a legal remedy against those who are responsible, but it will take generations for the suffering to lessen and the Amazon to heal. *Crude Reflections* helps to make the case that theirs is a just and equitable cause. Look at the photographs and decide for yourself if they have made their case.

The mission of the Foundation, created by the artist Oswaldo Guayasamin, is to disseminate art and defend culture. The Foundation achieves its mission in instances like this, when the Ecuadoran public is moved by the suffering and the drama of our blood brothers and sisters. Awakening the consciousness of the public—showing them the crude reality of aggressive exploitation of oil reserves in the Amazon—is a way of fulfilling our mission: to defend the cultural identity of our Nation.

PABLO GUAYASAMIN IS THE DIRECTOR OF THE GUAYASAMIN FOUNDATION.

reflexiones *por Pablo Guayasamín*

En junio de 2007, la Fundación Guayasamín presentó al público ecuatoriano una intensa muestra fotográfica titulada *Cruda Realidad*, cuyo impacto reverberó más allá de las fronteras de Ecuador. A través de los mágicos lentes de Lou Dematteis y Kayana Szymczak, *Cruda Realidad*—primero una exposición y ahora un libro—captura los devastadores efectos humanos y ecológicos provocados por Texaco (actualmente Chevron), una compañía petrolera que operó en la región amazónica ecuatoriana de 1964 a 1992. La exposición fotográfica revela la negligencia ambiental, la enfermedad y el sufrimiento que los destructivos procesos de extracción de petróleo causaron a los habitantes de las regiones de Orellana y Sucumbios y al planeta mismo.

Cruda Realidad representa un grito de dolor y desesperación humana y ecológica, surgido desde las regiones más remotas de la Amazonía. No se necesitan palabras para transmitir la urgencia de la situación, así como el legítimo derecho que los pueblos de las regiones de Orellana y Sucumbios tienen para exigir que sus demandas sean reconocidas, aceptadas y resueltas por los responsables.

¿Cómo compensar a la gente por la pérdida de vidas y el sufrimiento que la destrucción del ecosistema local ha provocado? Los pueblos indígenas y otros residentes del Amazonas buscan una solución jurídica contra los responsables del daño, pero pasarán generaciones antes de que el sufrimiento disminuya y la región del Amazonas se recupere. *Cruda Realidad* ayuda a demostrar que la suya es una causa justa y equitativa. Observe las fotografías y decida por sí mismo si respaldan sus argumentos.

La misión de la Fundación, creada por el artista Oswaldo Guayasamín, es divulgar el arte y defender la cultura. La Fundación logra su misión en instancias como ésta, cuando el público ecuatoriano se conmueve con las experiencias y el sufrimiento vividos por nuestros hermanos de sangre. Despertar la conciencia del público—mostrándole la *cruda realidad* de la agresiva explotación de las reservas petroleras en el Amazonas—es una manera de cumplir nuestra misión: defender la identidad cultural de nuestra nación.

PABLO GUAYASAMÍN ES EL DIRECTOR DE LA FUNDACIÓN GUAYASAMÍN.

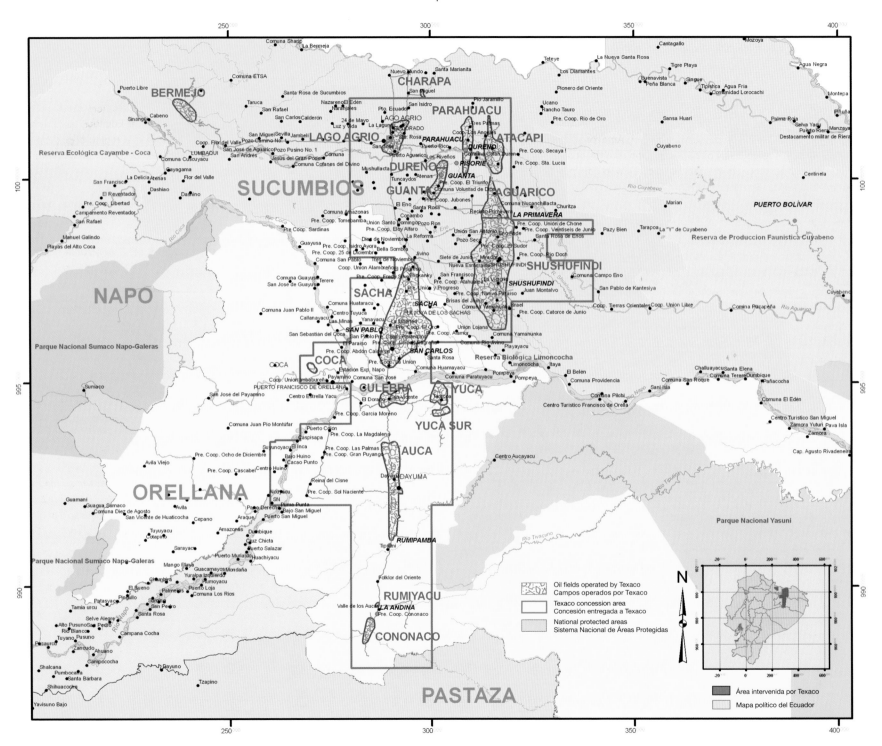

Legend:

- Oil fields operated by Texaco / Campos operados por Texaco
- Texaco concession area / Concesión entregada a Texaco
- National protected areas / Sistema Nacional de Áreas Protegidas

N

- Área intervenida por Texaco
- Mapa político del Ecuador

supporters | apoyo

AMAZON WATCH

Amazon Watch works with indigenous and environmental organizations in the Amazon Basin to defend the environment and advance indigenous peoples' rights in the face of large-scale industrial development. In Ecuador, Amazon Watch works in partnership with communities affected by oil contamination as a result of Texaco's (now Chevron) oil operation, and supports indigenous peoples who continue to defend their territories and cultures from oil extraction.

Amazon Watch trabaja con organizaciones indígenas y ambientales en la cuenca Amazónica para defender y fomentar los derechos de los pueblos indígenas que afrontan desarrollos industriales a gran escala. En Ecuador, Amazon Watch trabaja en asociación con las comunidades afectadas por la contaminación petrolera como resultado de la operación de Texaco (actualmente Chevron) y apoya a los pueblos indígenas que continúan defendiendo sus territorios y su cultura de la extracción petrolera.

Tel: (415) 487-9600
amazon@amazonwatch.org

www.chevrontoxico.com
www.amazonwatch.org

ACCIÓN LATINA

Accion Latina is a nonprofit organization based in San Francisco's Mission district that promotes social change and cultural pride in the Latino community through community journalism and cultural arts, and we publish the bilingual El Tecolote newspaper. In 2006, we were invited to serve as the fiscal sponsor for the Crude Reflections project and are proud to support such an important and illuminating project.

Acción Latina es una organización no lucrativa establecida en el distrito de la Misión en San Francisco que promueve cambios sociales y el orgullo cultural en la comunidad latina, a través del periodismo, la cultura y las artes. Nosotros publicamos el periódico bilingüe El Tecolote. En el 2006, fuimos invitados para ser patrocinadores fiscales del proyecto Crudas Reflexiones. Estamos muy orgullosos de apoyar tan importante y luminoso proyecto.

Tel: (415) 648-1045
accionlatina@accionlatina.org

www.accionlatina.org
www.eltecolote.org

PACHAMAMA ALLIANCE

The Pachamama Alliance was formed in response to a request from the Achuar, an indigenous people deep in the southern Amazon region of Ecuador, and currently works with all of the indigenous groups of this 5 million–acre region of pristine rainforest. Our strategy is to strengthen indigenous peoples' ability to speak powerfully and stand for their own rights and interests.

La Alianza de Pachamama nació en respuesta a una petición del pueblo Achuar, gente indígena viviendo en la parte profunda de la region del sur de la Amazonía ecuatoriana y trabaja actualmente con todos los grupos indígenas de esta región de 5 millones de acres de selva Amazónica prístina. Nuestra estrategia es de reforzar la capacidad de los grupos indígenas para hablar poderosamente y para defender sus propios derechos e intereses.

Tel: (415) 561-4522
info@pachamama.org

www.pachamama.org

FUNDACIÓN GUAYASAMÍN

The Guayasamin Foundation was created by Ecuadoran artist Oswaldo Guaysamin who believed in social solidarity and the integration of peoples. The mission of the Foundation is to provide a public forum for artwork and to defend culture. The Guayasamin Foundation Museum and its cultural complex, "The Chapel of Man", are located in Quito, Ecuador.

La Fundación Guayasamín fue creada por el artista Oswaldo Guayasamín, quien creía en la solidaridad social y la integración de los pueblos. La misión de la Fundación es ofrecer un foro público para el arte y defender la cultura. El Museo Fundación Guayasamín y su complejo cultural, "La Capilla del Hombre", están situados en Quito, Ecuador.

Quito, Ecuador
Tel: 593-2-2446455 / 2452938 / 2465266

www.guayasamin.com
guayasam@uio.satnet.net

credits | créditos

Production Director | Director de Producción: Lou Dematteis

Design | Diseño: Marcela Reyes <mreyesinfo@gmail.com>

Publishing Advisor | Asesor Editorial: Jack Howell

Photo Imager | Editor de Imágenes: Bryan Bailey

Aerial Photo Artist | Artista de Fotografías Aéreas:
John Quigley (pgs./págs. 74-75 & 90-91)

Translators | Traductores: Elisa Bravo, Susana Cordero,
Mitch Anderson, Carol Tonelli, Jane Kelly, Rosa Maria Dueñas-Rios,
Blair Sly, Kellie Kemp, E. Bell, David Gamon, Chris Scrogum.

aknowledgments | reconocimientos

Humberto Piaguaje, Toribio Aguinda, Emergildo Criollo, Patricia Gualinga, Gilberto Cuyo, Pablo Guayasamín, Verenice Guayasamín, Laszlo Karoli, David Cevallos, the Amazon Jungle Ecological Reserve, Kapawi Lodge, David Titcomb and the Titcomb Foundation, Dune Lankard, the Open Society Institute, Randy Hayes, the Levinson Foundation, Elaine Katzenberger, Carolina Ponce de León, Faera Siegel, Rene Yañez, Robert Gumpert, Walter Aguilera, Han Shan, Maria Fonseca, Kim Komenich, Ken Light, Kathleen Hennessy, Susan Meiselas, Ken Kobre, Donna Ferrato, Gabriela Dematteis, Tom Kelly, Atossa Soltani, Kevin Koenig, Jennifer DeLury Ciplet, Leila Salazar, Simeon Tegal, Marianne Monnin, Eva Martinez, Amy O'Meara, Martha Nicolau, Magda Alarcón, Susana Aragón, Johanna Mandel, Bernd Debusmann, Win McNamee, Rick Rocamora, Marcel Saba, Stephanie Alston, Bill Twist, Daniel Koupermann, Daryl Hannah, John Quigley, Eduardo Galeano, Trudie Styler and Sting.

Special Thanks | Agradecimiento Especial: Megan Wiese.

Pictopia, Gamma Photo Lab, Colortone.

Fundación Guayasamín, Casa de la Cultura Nucleo de Sucumbíos, Acción Latina, Amazon Watch, Pachamama Alliance, Amnesty International, KyotoUSA.

other resources | recursos adicionales

Amnesty International USA | Amnistía Internacional USA
Amnesty International's Business and Human Rights Chevron Fact Sheet
Informe de la división de Negocios y Derechos Humanos de Amnistía Internacional sobre los hechos de Chevron:

www.amnestyusa.org/business/sharepower/chevron_factsheet.html

Yasuni National Park | Parque Nacional Yasuní
For more information on the campaign to save Yasuni National Park:

www.liveyasuni.org www.sosyasuni.org

Para más informacion acerca de la campaña para salvar al Parque Nacional Yasuní:
www.amazoniaporlavida.org/es/index.php

Amazon Defense Front | Frente de Defensa de la Amazonía
English: www.texacotoxico.org/eng Español: www.texacotoxico.org

The Rainforest Foundation
UK: www.rainforestfoundationuk.org US: www.rainforestfoundation.org

testimonies | testimonios

The selection of the cases and testimonies included in this book was done very carefully. Medical personnel in Ecuador alerted us to the majority of the cases and we interviewed each of the affected parties and/or their families in person. For most of the cases, we were able to view medical records and, in the case of those who had died, their death certificates.

Los casos y testimonios incluidos en este libro fueron cuidadosamente seleccionados. Personal médico del Ecuador nos alertó sobre la mayoría de estos casos y entrevistamos a cada una de las partes afectadas y a algunas de sus familias en persona. En casi todos los casos pudimos ver los expedientes médicos y los certificados de defunción de las personas que fallecieron.

photographs | fotografías

Photos taken between 2003 and 2007 unless otherwise noted.
Las fotos han sido tomadas entre 2003 y 2007, a menos que se indique lo contrario.